IMAGES
of America

SCOTTSDALE

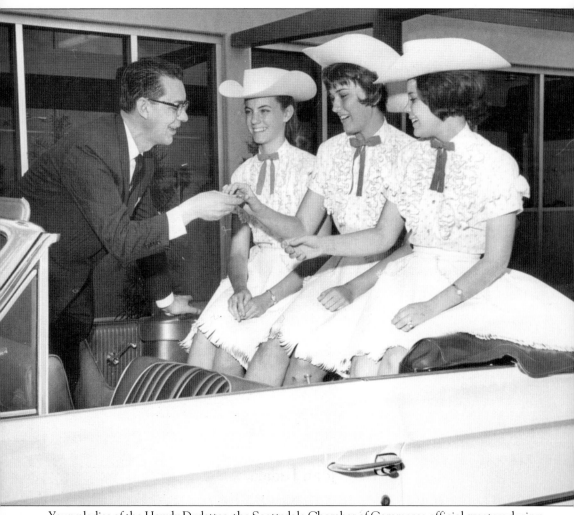

Young ladies of the Howdy Dudettes, the Scottsdale Chamber of Commerce official greeters during the 1960s and 1970s, represented just one of the many friendly ways Scottsdale has welcomed visitors to town throughout its history. These unidentified mid-1960s high school coeds are sharing a smile with Scottsdale mayor C. W. Clayton. (Scottsdale Historical Society.)

ON THE COVER: Scottsdale namesake Chaplain Winfield Scott (bearded man on left side of photograph as it wraps to the back of the book) and his fellow 1890s settlers enjoyed outings in the exotic desert that drew them West. The Hole-in-the-Rock formation, now part of Papago Park, was a popular picnic spot. (Scottsdale Public Library.)

IMAGES
of America

SCOTTSDALE

Joan Fudala

Arizona Historical Foundation

ARCADIA
PUBLISHING

Published by Arcadia Publishing
Charleston SC, Chicago IL, Portsmouth NH, San Francisco CA

Printed in the United States of America

Library of Congress Catalog Card Number: 2006935207

For all general information contact Arcadia Publishing at:
Telephone 843-853-2070
Fax 843-853-0044
E-mail sales@arcadiapublishing.com
For customer service and orders:
Toll-Free 1-888-313-2665

Visit us on the Internet at www.arcadiapublishing.com

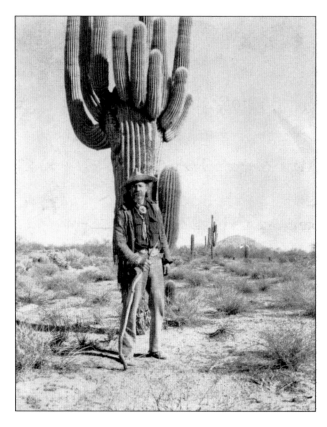

A colorful and mysterious character, Don Pablo perhaps represents an "outsiders" stereotyped image of a Western mountain man. Pablo—one of a kind and not typical of most Scottsdale residents—was a self-described Indian trader who sold his curios from a sprawling stand at remote Curry's Corner, now the busy intersection of Scottsdale and Pinnacle Peak Roads. (Scottsdale Historical Society.)

CONTENTS

ACKNOWLEDGMENTS

Perhaps the first thing to acknowledge when assembling a photographic history of a community is that not every historical event or person was captured on film. This is particularly true of Scottsdale, which was a tiny farming community through World War II. With that in mind, I have attempted to ferret out rarely seen photographs from archives, organizations, businesses, and family albums in order to create a visual collage of this multifaceted community. I have tried to create a balance between what a visitor might find interesting and what a longtime resident might find nostalgic about Scottsdale. My apologies to those people and events who wish they had been included—I had a page limit!

I want to thank several people and the historic archives they represent for leading me to some great images: Leigh Conrad at the Scottsdale Public Library, Joann Handley at the Scottsdale Historical Society, Elizabeth Scott and Jared Jackson at the Arizona Historical Foundation, Maggie Wilson and Mike Phillips at the City of Scottsdale Communications and Public Affairs Department, Kim Rose at the First Baptist Church of Scottsdale, Sr. Alice Ruane at Our Lady of Perpetual Help Church-Scottsdale, and Shelly Dudley at Salt River Project. I could do a book on each of their photograph collections.

Researching a book like this allows one to make new friends and touch base with those we turn to often for historic verifications. I particularly want to thank Paul Messinger, Marshall Trimble, Labeula Steiner Mowry, Jose Maria Burruel, Earl Eisenhower Jr., Janie Ellis, Leslie Nyquist, Rob Spindler, Virgie Lutes Brown, Mae Sue Talley, and Fran Brennan for helping me gather historical facts, figures, and photographs. I truly appreciate the encouragement Arizona Historical Foundation executive director Jack August and Arcadia Publishing West Coast publisher Christine Talbot have given me. They are all true believers in the importance of researching, restoring, and celebrating community histories. Lastly, one can never do a book alone. My husband, Gene, using his pilot's attention to detail, helped with editing.

I urge all who flip through these pages to be inspired to do some spring cleaning and donate photographs—even if they are just 10 years old—to a local historical society, library, or archive. Today's technology makes this so easy. Students, genealogists, historians, teachers, and city planners will thank you as they do their research, and you will be leaving behind a legacy of your family, business, church, or civic group.

INTRODUCTION

Scottsdale today bears little resemblance to the farming village founded by a Baptist minister in 1888 in the remote desert east of Phoenix, Arizona. Visitors staying in today's five-star resorts are astounded to find that glitzy, glamorous Scottsdale started as a completely temperate ("dry") colony of educated Christians who eked out a modest living by cultivating citrus, cotton, and other crops, and raising cattle. Like the Hohokam people who lived on the land before them, these hearty pioneers found that with lots of water and sweat equity they could grow just about anything in the Salt River Valley.

During the first two decades of Scottsdale's settlement, residents spent much of their time adapting to the arid conditions of the undeveloped Sonoran Desert. Photographs of the 1890s farming village of Scottsdale show a life without electricity, running water, telephone service, paved streets, or variety in retail services. Many of the early residents gave up such lifestyle necessities when they left their previous lives in the Midwest or Northeast in the late 1800s to early 1900s for health or wealth opportunities "out west." Despite hardships, they built homes, schools, churches, and a close-knit way of life that epitomized the American dream of hard work equaling a successful life.

Scottsdale's earliest "resorts" were canvas and wood-frame cottages at small, privately owned health camps, where frail individuals came to restore their health in the sunny, dry climate. The popularity of these early-1900s camps later helped establish Scottsdale's reputation as a wellness center, carried on today by Mayo Clinic Scottsdale, Scottsdale Healthcare, and others. Guest ranches began to sprout up to accommodate winter visitors at the turn of the 20th century, proliferated after World War II, and morphed into luxury golf and spa resorts during the 1980s. Residents and visitors have enjoyed the adventures that the Sonoran Desert and McDowell Mountains offer, from horseback riding to picnics and hiking, to reveling in wide-open spaces under clear blue skies or star-studded nights.

The beauty of Scottsdale's natural environment began attracting artists like Marjorie Thomas as early as 1909. Frank Lloyd Wright furthered Scottsdale's fame when he established a winter home and architectural school in Scottsdale in 1937. The Arizona Craftsmen Center that opened in Scottsdale in 1946 included many rising stars among Native American artists and craftsmen as well as artists returning from World War II service.

Through World War II, the Scottsdale economy was driven by agriculture, with cotton becoming the major cash crop around 1913. After the war, farmland gave way to residential developments, resorts, shopping centers, schools, and parks as Scottsdale grew into the urbane, urban oasis it is today. A host of colorful characters—locals and visiting celebrities—gave Scottsdale a charisma that continues to garner national media coverage. Scottsdale's enduring slogan, "The West's Most Western Town," although coined by merchants in the late 1940s, still defines the city as a blend of Western cultures, architecture, cuisine, and camaraderie.

For the first 63 years of its settlement, Scottsdale remained an unincorporated little burg east of Phoenix. With the postwar boom in business, tourism, and population, Scottsdale finally incorporated as a town in 1951.

Scottsdale is a relatively young city in a very old place. Settled among the ruins of at least two ancient civilizations, the area has a history rich in Western, Native American, Hispanic, and Sonoran Desert legend and lore. Its residents have embraced art and culture, welcomed visitors to share their natural and man-made assets, and created a great place to live, work, visit, play, and raise a family. This book presents snapshots from Scottsdale's first century, from 1888 to 1988. Now well into its second century, Scottsdale—thanks to its retinue of involved citizens and blend of cultures—continues to make history every day.

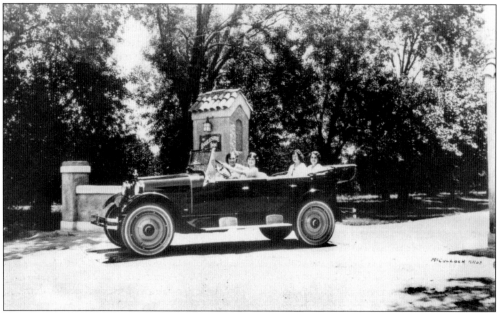

Visitors and residents, young and old, have been having fun in the sun in the Scottsdale area since shortly after its founding in 1888. The Ingleside Inn on Indian School Road and Fifty-sixth Street was the area's first luxury resort and was an easy but dusty horse-and-buggy, or later car, ride from the Scottsdale town site. (Scottsdale Public Library.)

One

PRELUDE TO PARADISE
SOWING THE SEEDS
FOR A DESERT COMMUNITY

Humans have been visiting Scottsdale for over 8,000 years, a fact only learned in the past 40 years. While surveying Scottsdale's land for developers and the city, archaeologists discovered evidence that Archaic people were seasonal hunters in Scottsdale's northernmost area as far back as 6,000 B.C. Two groups of more permanent residents, the River and Upland Hohokam people, arrived about 2,000 years ago. The Hohokam people hand-dug canals from the Salt River or tapped into mountain springs for water and farmed the land until the mid-1400s. Although as a people they mysteriously disappeared, the members of the Salt River Pima-Maricopa Indian community are most likely descendants of the Hohokam. Spanish explorers ventured north from Mexico in the 1500s but probably did not set foot on Scottsdale's land. The first real evidence of modern-day settlement of Scottsdale and the Salt River Valley came with the United States Army in 1865.

When the Civil War ended, there was great interest in migrating to the Western United States, including the recently created Arizona Territory. To provide protection to miners, trappers, ranchers, adventurers, and settlers, the army established a post at the confluence of the Salt and Verde Rivers and called it Camp McDowell. When the camp's namesake, Maj. Gen. Irvin McDowell, visited in 1866, he was appalled to find soldiers spending much of their time trying to grow food crops for themselves and their horses. He immediately ordered the camp's commander to find civilian contractors who would be willing to come to the Salt River Valley to grow crops for the fort. Civil War veteran Jack Swilling was one of those who answered the call, and he rediscovered the remnants of the Hohokam canals along the Salt River, dug them again, and established a hay camp near the Salt River that became the town of Phoenix. In order to get hay to Camp McDowell, soldiers and civilians traveled over various parts of what is now Scottsdale.

Other towns began along the Salt River—in those days before dams and other diversions it was a regularly flowing river—like Tempe and Mesa. As the number of settlers grew from hundreds to thousands, more water was needed to support farming and living. William J. Murphy, an experienced railroad construction contractor, won the bid to build a major canal system that was the first to depart from the ancient Hohokam ditch network. He and his crew began the Arizona Canal work in 1883, finishing in 1885. Land along its route became quite attractive for investment and settlement. The recently enacted Desert Lands Act also encouraged settlement, as did the start of rail service to Maricopa, near the Salt River Valley, in 1887. By 1888, the seeds were sown for Scottsdale's development.

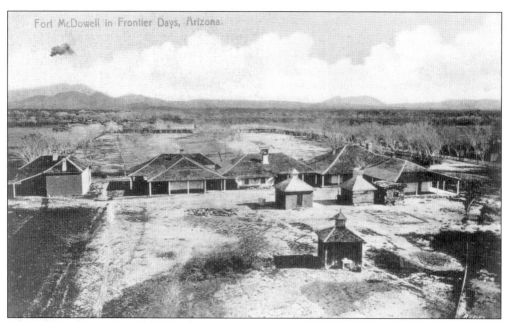

In 1865, the U.S. Army established Camp McDowell at the confluence of the Salt and Verde Rivers. Men and materiel arrived via long, hot, dusty treks across the desert; at the time there was no train service to the Arizona Territory. (Arizona Historical Foundation.)

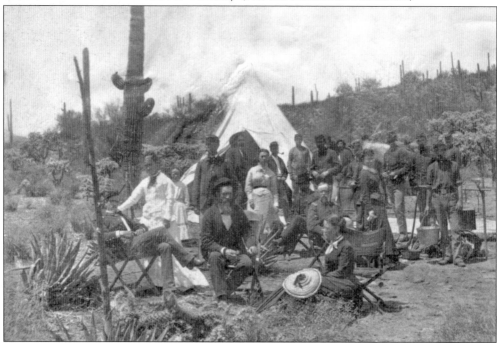

Life at Camp McDowell was harsh, without modern conveniences of the era. Despite the primitive conditions, some of the officers brought along their wives and children. Army wife Martha Summerhayes documented her experiences in a book *Vanished Arizona*. Officers, soldiers, and families of the 6th Cavalry, 8th Infantry ventured into the desert for picnics and recreation, as seen here. (Arizona Historical Foundation.)

Camp McDowell honored Maj. Gen. Irvin McDowell, commander of the Pacific, whose headquarters were in San Francisco. McDowell thrived in his new role of protecting and developing the West after suffering major battle losses in the Civil War. Records indicate he visited his namesake post only once, in February 1866. Using the name of the encampment as a springboard, the McDowell Mountains, McDowell Road, and Mount McDowell (now Red Mountain) all bear his name. (National Archives, Brady Collection, No. 111-B-3810.)

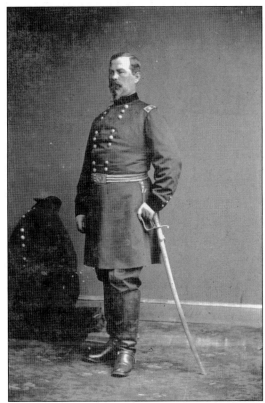

Through the 1880s, D Troop of the 4th Cavalry trained at the post that had been renamed Fort McDowell. The fort's strategic position declined as settlers, the territorial and federal governments, and Native American tribes entered an era of peace. By the time the army decommissioned the fort in 1890, Phoenix was a thriving city, and Scottsdale had a few settlers. The federal government turned the post's land over to form the Fort McDowell Yavapai Nation in 1903. (Arizona Historical Foundation.)

William J. Murphy turned his railroad construction expertise toward a new venture when he got the contract to build Arizona Canal in the Salt River Valley in 1883. He traveled throughout the United States to raise money for completion of the canal and to promote the opportunities the waterway and its water would bring to investors and settlers. While he was away, his wife, Laura Fulwiler Murphy, managed construction of the canal, living in a tent on-site with their children and moving as the work progressed. (Scottsdale Public Library.)

Five hundred men and 300 mules were involved in building the Arizona Canal, which cost about $700,000 to construct. It ran from the old Arizona Dam, on the Salt River near the mouth of the Verde River, west toward the Agua Fria River. Once the canal was operating in 1885, canal builder Murphy accumulated land along its route and created an area he called Ingleside. (Arizona Historical Foundation.)

Two

WATER AND PEOPLE
LIFE COMES TO THE LAND
1888–1910

The new Phoenix Chamber of Commerce invited well-known U.S. Army preacher and promoter of the West, Winfield Scott, to the Salt River Valley in February 1888. They hoped he would evangelize about the area's many opportunities during his travels. The boosters' plan worked well. Within months, Scott and his wife, Helen, filed a homestead claim on 640 acres of land along the new Arizona Canal, committing to pay $2.50 an acre for the undeveloped tract of desert east of Phoenix. Since he was still on active duty in the San Francisco area, Scott sent his brother George to establish a ranch on his land.

After retiring from the army in 1893, Chaplain and Mrs. Scott came to the Salt River Valley as full-time residents. An adept farmer, he successfully raised a variety of crops on his ranch. He also filled pulpits around the Arizona Territory, encouraging all he met to join him in creating a desert farming community. Some came to restore their health, some came for a new start, and others came for the sheer adventure. Most of the original town settlers were educated, Protestant, family oriented, and not afraid of hard work. They were also a temperate group and vowed never to have liquor available in their new settlement.

Albert G. Utley bought 40 acres south of Scott's ranch, with plans to create a town he dubbed "Orangedale." Scott and Utley laid out the plan for the town site, but when Utley filed it, the name was changed to honor Scott. The settlement was first called Scotts Dale in 1894. In measured steps, the village grew. There were just enough children in the community to form a school district in 1896. In 1897, the first general store, post office, and commercial inn opened.

Farming was the primary Scottsdale occupation during the late 1800s and early 1900s. As long as water could be diverted via ditches and laterals off the Arizona Canal to irrigate land, crops and livestock thrived. When the Salt River Valley Water Users Association formed in 1903, it created new dams and canals, and water was more assured but not a given. Droughts and floods still plagued Scottsdale and other nearby towns. Water was big business, but it was also a source of cooling pleasure, especially in the 100-degree summers before Scottsdale had electricity or air-conditioning.

The Arizona Territory was still an arduous journey from Midwest and East Coast suppliers, so residents made do with what they could from the desert. Starting with Chaplain Scott, residents sought the advice of their neighbors on the Salt River Pima-Maricopa Indian Community to teach them how to build brush ramadas onto their tent homes. The hearty folks of Scottsdale shared what they had, celebrated holidays together, worshipped ecumenically, and opened their homes and land to winter visitors and new residents until they could get established.

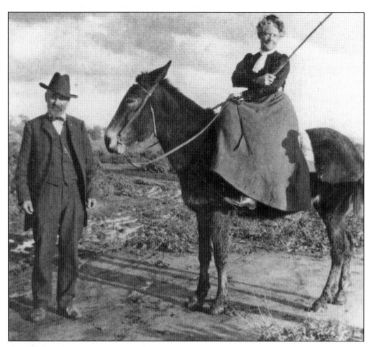

The Reverend Winfield and Helen Scott became full-time residents in 1893 after Scott retired as an army chaplain. When he returned to the land he had purchased in 1888, he also brought along a retired army mule, affectionately named Old Maude. Both Scott and Old Maude had bullet wounds in their legs; Scott's from the Civil War. Helen was an accomplished poet, public speaker, and mother of their three grown girls. (Scottsdale Public Library.)

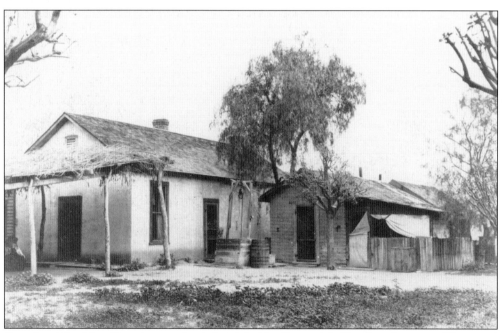

Scott's original land purchase today is bounded by Scottsdale Road to the west, Chaparral Road to the north, Hayden Road to the east, and Indian School Road to the south. His farming experiments, mostly successful, included citrus fruit, grapes, figs, barley, alfalfa, plums, pears, oats, nectarines, raisins, peaches, apricots, peanuts, sweet potatoes, potatoes, and almonds. Due to the high cost of Arizona Canal water rights, he sold much of his acreage but kept over 100 acres on which to farm. (Scottsdale Public Library.)

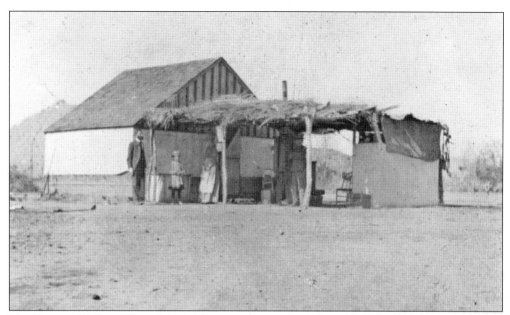

The Reverend Judson Elliott built his home with a picturesque view of Camelback Mountain and near his friends, the Winfield Scotts. Canvas flaps on the side of wood-frame tent homes like the Elliotts' were raised in hopes of a cool breeze. Cooking was done under a brush ramada to keep the interior of the tent home cooler and for fire safety. Without electricity, perishable food was kept in a "desert cooler" whose technology involved the evaporative effects of wet burlap over a wood frame. (Scottsdale Public Library.)

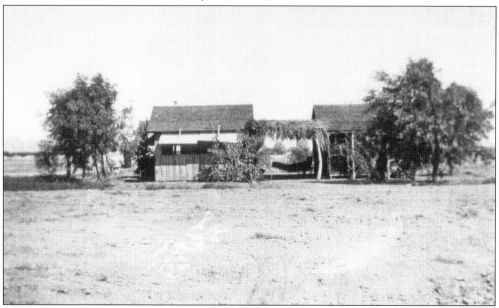

In 1903, newlyweds Walter and Helen Smith, the first couple married in Scottsdale, moved into this tent home on Indian School Road. Like other Scottsdale residences, their tent home featured a covered porch or ramada where they could sleep in hammocks during the summer to keep cool. Some even wrapped themselves in wet sheets during extremely hot nights. (Scottsdale Public Library.)

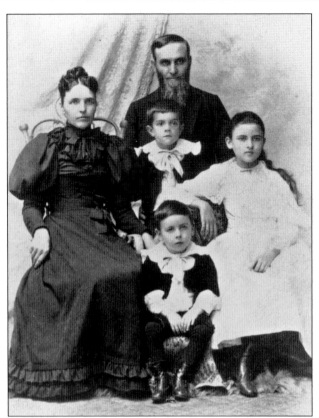

George and Alza Blount moved to Scottsdale in 1896 with their children, William, Herb, and Bertha. They bought 40 acres southeast of the town site to use for farming and built an adobe house that, years later, would have many uses. He was a teacher in Phoenix; she became Scottsdale's first teacher after residents built the town's schoolhouse in 1896. (Scottsdale Public Library.)

Like most children in 1890s Scottsdale, William and Herb Blount had farm chores to do before and after school. Here the boys are tending their dairy cows; citrus trees grow behind them, with Camelback Mountain in the distance. The Blount's plot of land would today encompass the eastern part of Civic Center Mall and the area southeast of Civic Center Library. (Scottsdale Public Library.)

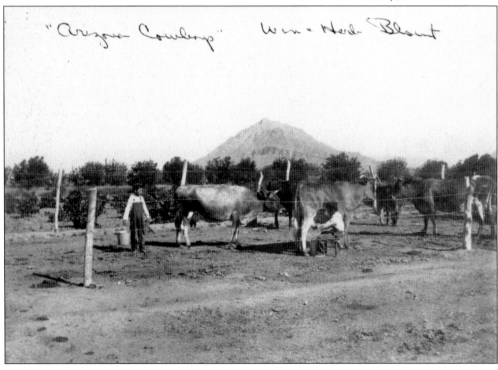

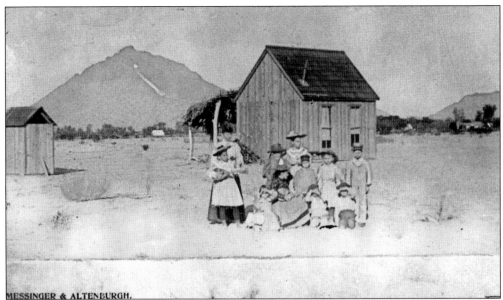

Winfield Scott, Frank Titus, and John S. Tait comprised the first Scottsdale School Board when the school district formed in July 1896. Albert Utley donated three acres for a new school, and the residents gathered on a September Saturday to erect the one-room wooden building. It was located approximately 10 yards east of what later became Scottsdale's second school, known as the Little Red Schoolhouse and, after many other uses, the Scottsdale Historical Museum. (First Baptist Church of Scottsdale.)

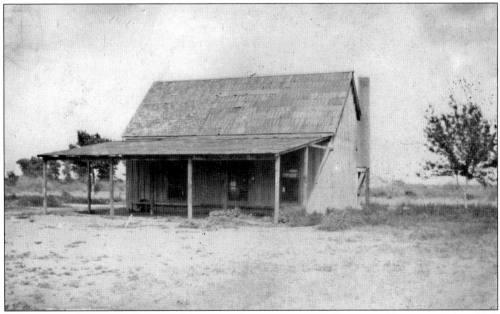

Seventeen children attended school during its first week in 1896. During its 14 years as Scottsdale's only school, the building was expanded three times to accommodate more students. On Sundays, the town held church services in the schoolhouse. On Arbor Day 1898, students planted ash trees around the school provided by Chaplain Scott, who often came to the school to tell the students about the Civil War. (First Baptist Church of Scottsdale.)

J. L. Davis opened the settlement's first general store in 1897 and became Scottsdale's first postmaster when the post office was established in his store that same year. Davis also helped build the Presbyterian Church on the Salt River Pima-Maricopa Indian Community. (Scottsdale Public Library.)

J. L. Davis and his family lived behind their general store, which was located on what is today the intersection of Brown Avenue and Main Street. Sarah Coldwell Thomas bought the store from Davis and ran it for many years in partnership with her brother-in-law E. O. Brown. (Southwest Studies, Scottsdale Community College, Marshall Trimble.)

Scottsdale residents at the turn of the 20th century traveled by horse and buggy along unpaved Indian School Road, the dirt path in the center of the photograph, when they needed goods and services available only in Phoenix. Through World War II, only Scottsdale Road was partially paved; dust was a perennial problem. (Arizona Historical Foundation.)

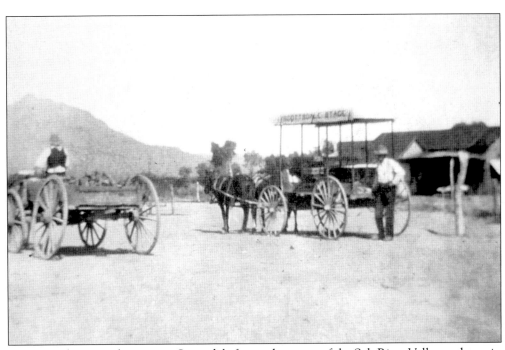

Visitors and new residents got to Scottsdale from other parts of the Salt River Valley or the train depot in Maricopa via the horse-drawn Scottsdale Stage. Two stage lines operated between Phoenix and Scottsdale by 1905, but they were eventually replaced by gasoline-powered stages or buses. (Southwest Studies, Scottsdale Community College, Marshall Trimble.)

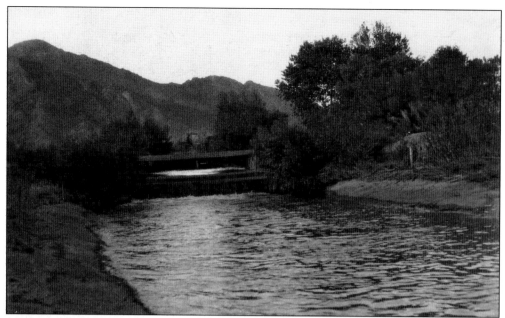

In 1888–1889, William J. Murphy's Arizona Improvement Company built the four-mile-long Crosscut Canal, linking the Arizona and Grand Canals. This new canal provided better distribution of water but also gave residents recreational destinations—23 waterfalls along its route. Scottsdale residents often rode their horses or took picnics to the Arizona Falls, located on Indian School Road and Fifty-sixth Street. (Arizona Historical Foundation.)

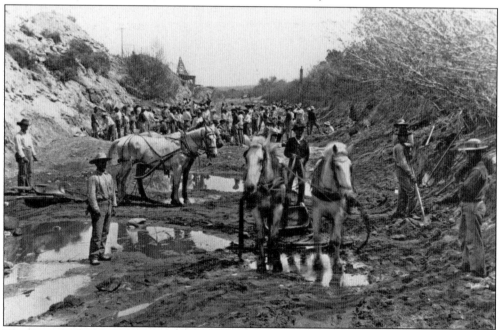

The Arizona Canal, lifeblood to Scottsdale farmers and ranchers, required constant upkeep. In 1900, men worked to deepen the canal; in 1909–1910, the canal needed dredging. Work on the waterway drew new settlers from California and Mexico who often stayed in Scottsdale when the work was completed. (Scottsdale Public Library.)

In the 1890s, promoters attracted investors to a plan to bring water from the Verde River to irrigate "Paradise Valley," the land west of the McDowell Mountains. Construction for the Rio Verde Canal began, but the canal was never completed and never used. As these well-dressed visitors demonstrate, the miles-long canal berm north of Scottsdale became a popular place for outings. Today a sign on the Sanctuary Golf Course north of Frank Lloyd Wright Boulevard identifies a portion of the remaining canal berm. (Arizona Historical Society.)

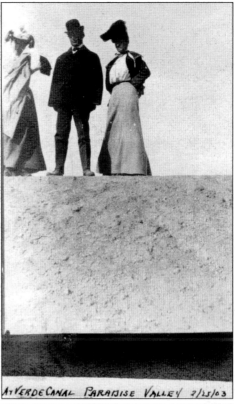

AT VERDE CANAL PARADISE VALLEY 2/25/03

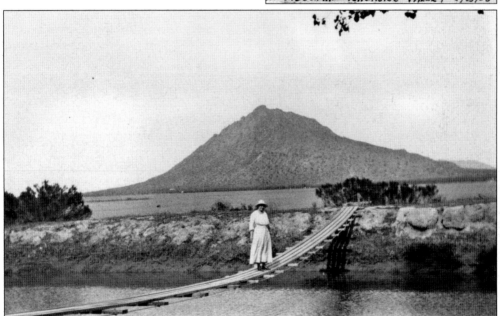

Residents like Elizabeth Kimsey used walking bridges to cross over wider segments of the Arizona Canal. Beavers lived along canal banks and their laterals. The furry water animals provided inspiration for the Scottsdale High School team name, the Beavers. (Scottsdale Public Library.)

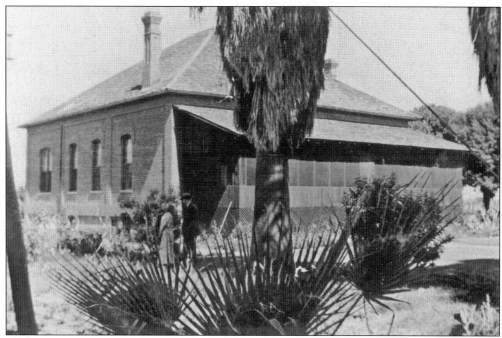

Not all Scottsdale settlers lived in tent homes. Railroad executive Frank Titus built a territorial-style home and stables south of the Scottsdale town site in 1892. This 1920s view shows the home when the Stevenson family lived on the Hayden Road ranch. Still occupied as a residence in 2006, the Titus House is Scottsdale's oldest building and is listed on the National Register of Historic Places. (Scottsdale Historical Society.)

Howard and Ida Underhill built a home on Scottsdale Road (then called Paradise Road) across from the Scott's ranch in 1897. The Underhills called their large, modern home with spacious, tree-shaded grounds Oasis Villa and began to accept paying guests. Scottsdale's thriving resort industry today can trace its roots to the Underhills. (Scottsdale Public Library.)

Scottsdale founder and namesake, Winfield Scott, was a man of boundless energy. In addition to farming and preaching, he was elected to the Arizona Territorial House of Representatives in 1898. According to Scott's biographer, Richard Lynch, when the new territorial capitol building was dedicated in Phoenix in 1901, Scott was among the group on the platform. (Arizona State University Libraries, Arizona Collection, Ryder Ridgway Photographs.)

Educated at the Museum School of the Boston Museum of Fine Arts, Marjorie Thomas came to Scottsdale with her mother and brother in 1909 and became the town's first resident artist. She had a fondness for animals of all kinds and painted a portrait of Scott's mule Old Maude. Her paintings of town scenes capture the essence of early Scottsdale. She once accompanied adventure author Zane Grey on a research trip to Northern Arizona. (Scottsdale Public Library.)

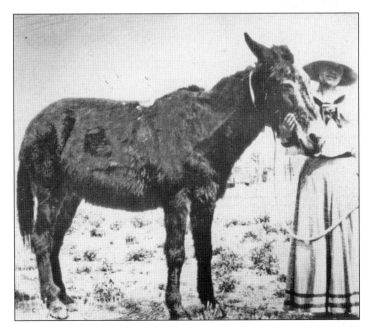

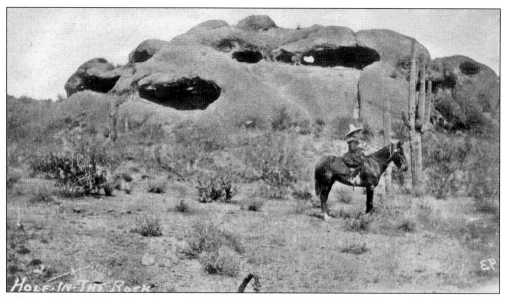

The desert provided endless opportunities for adventure to the children of Scottsdale. When school and farm chores were over, the youth of Scottsdale explored nearby canals and rock formations by horseback. This unidentified youth is posing south of the Hole-in-the-Rock formation, located north of today's Phoenix Zoo in Papago Park. (Arizona Historical Foundation.)

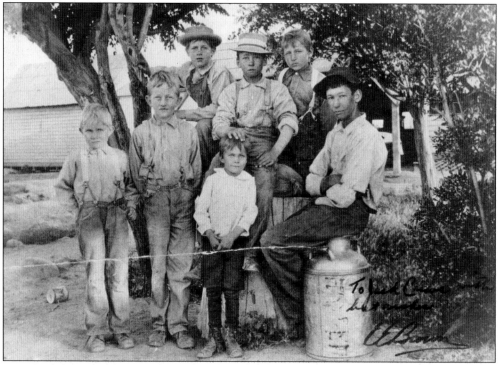

Boys from the Hayden, Brown, Thomas, and Coldwell families hung out at one another's farms and ranches after school around 1910. Without traffic, they could play marbles and other games in the middle of Scottsdale Road, shaded by tall cottonwood trees. As adults, these boys helped start or build many Scottsdale businesses and organizations. (Scottsdale Public Library.)

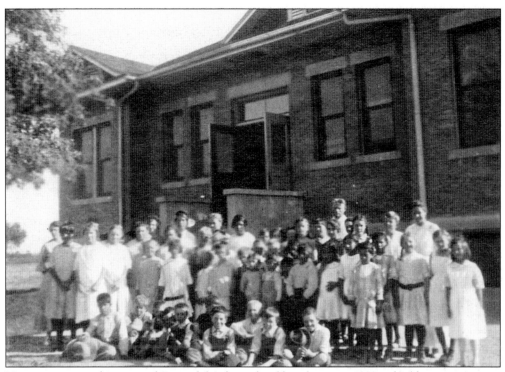

Voters unanimously approved Scottsdale's first school bond issue in 1909 to build a new grammar school. The 45- by 40-foot building cost $5,000 and was dedicated on town founder Winfield Scott's birthday, February 26, 1910. Arizona territorial governor Richard E. Sloan and the governor of Indiana Thomas Marshall (who would become U.S. vice president and a Scottsdale resident) gave dedication addresses. The first year, 32 students attended classes that were taught by one teacher. (Scottsdale Historical Society.)

Throughout its first decades, Scottsdale Grammar School attendance was impacted by Scottsdale's farming economy, with students often taking time off to help with crops, milking, and harvesting. Children either walked over unpaved streets or rode their horses to school. The school basement included an auditorium, the scene of many community events. Grammar school students participated in the annual Spring Flower Show. (Scottsdale Historical Society.)

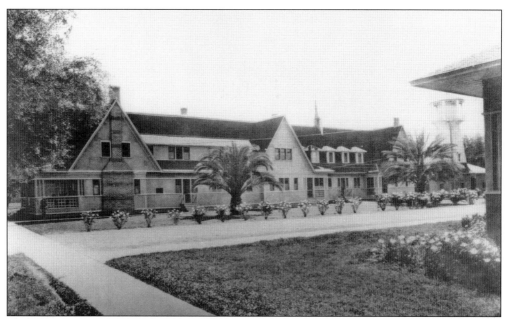

William J. Murphy and his son Ralph opened the area's first luxury resort in 1909–1910, the Ingleside Club, which was later renamed Ingleside Inn. At first a private club for potential investors in Murphy's developments, Ingleside was located in his citrus grove along Indian School Road and approximately Fifty-sixth Street. Its slogan, "Where summer loves to linger and winter never comes," helped attract wealthy and celebrity visitors from the Midwest and East Coast to come for the winter season. (Scottsdale Public Library.)

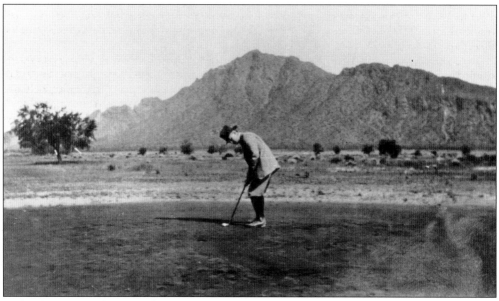

Ingleside Inn brought golf to the Scottsdale area. A far cry from today's lush, championship links, the Ingleside golf course had dirt fairways and oiled sand greens. Grass was introduced in the 1920s. The Arizona Country Club golf course incorporated much of the Ingleside course into its layout. (Scottsdale Public Library.)

Three

FARMING AND FAMILY
SCOTTSDALE DEVELOPS CHARACTER
1911–1930

When Chaplain Scott died in 1910, he left a letter to his fellow townsfolk that stated, in part, "I leave to you my work in Scottsdale. . . . If you take this work and do it, and enlarge it as God gives you strength, you will receive my blessing and His." Thus began a period of modest growth for Scottsdale, encouraged not only by Scott but also by the assured water supply from the new Roosevelt Dam (1911), cotton as a new cash crop, and an eclectic mix of newcomers.

The 1911 *Arizona Business Directory* listed Scottsdale's population as 100; however, dozens more lived on farms and ranches in the area now considered Scottsdale. Although people from Mexico had settled in the Salt River Valley for decades, more came north for work opportunities from 1913 to 1920. Ranchers sponsored families to immigrate to Scottsdale and, once here, the new residents formed a tight-knit community of full-time and seasonal workers living along Second Street and east of Brown Avenue.

To accommodate new residents, health seekers, and wealthy seasonal visitors, a few guest ranches opened in Scottsdale. Several retail stores opened along Main Street and Brown Avenue. Scottsdale got its first bank, café, service station, pool hall, drugstore, electric and water companies, icehouse, and barbershop during this period. Residents and businesses clustered around the original town site. However, some ranchers took their operations north of Scottsdale, where thousands of acres of undeveloped land could accommodate large herds of cattle and sheep.

Growth demanded more schools. Between 1918 and the early 1920s, the school district erected wooden classroom structures on the grounds of the Scottsdale Grammar School. In 1923, Scottsdale opened Scottsdale High School, and in 1928, the district opened a new Scottsdale Grammar School, turning the Little Red Schoolhouse into a "head start" style school for immigrant children in grades one to three.

Numerous civic groups formed during this period—a chamber of commerce, woman's club, parent-teacher association, the Baptist Young People's Union, a volunteer-run library, and the Scottsdale Blues men's athletic club. Although town founder Scott had urged ecumenical worship when the town was small, after his death, residents began to form separate congregations and moved their services from the schoolhouse to newly built churches.

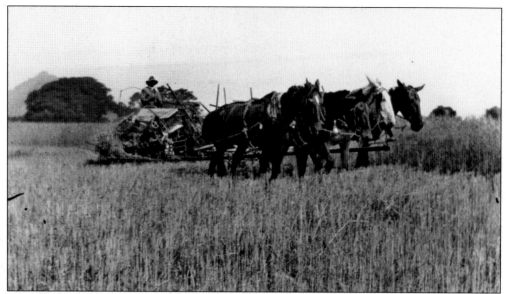

Much of Winfield Scott's farmland passed to William Miller around 1908. Like Scott, Miller and his farmhands successfully cultivated alfalfa on the land, as seen here. Miller died in 1923, just before Scottsdale High School opened on his property, which fronted Indian School Road. (Scottsdale Public Library.)

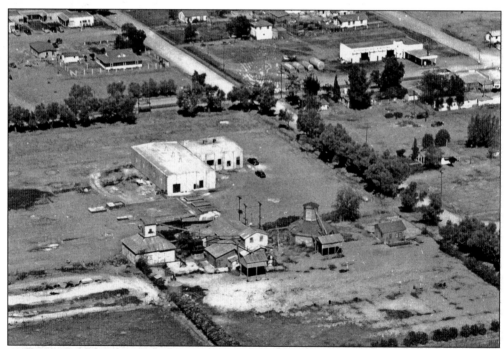

As cotton grew in importance to Scottsdale's economy, farmer and entrepreneur E. O. Brown and partners opened the Scottsdale Ginning Company in 1920 on Second Street east of Scottsdale Road. Scottsdale's cotton industry attracted workers and their families from Mexico, who established both temporary and permanent homes within blocks of the cotton gin. (Scottsdale Historical Society.)

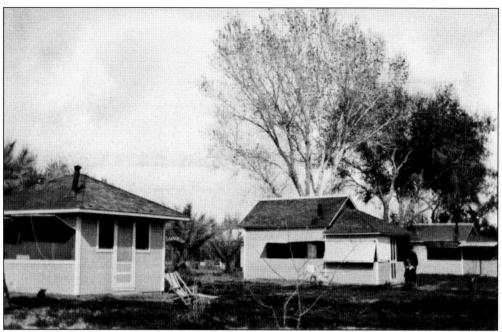

Ed and Mary Graves purchased the northwest corner of Scottsdale and Indian School Roads from the Howard Underhills and opened Graves Guest Ranch c. 1910. Catering to guests needing a place to recuperate as well as winter visitors and new residents, the Graves also ran an Indian Trading Post. Convalescing guests spent the winter season in bungalows with canvas sides in order to benefit from the dry desert air. Guests at Graves Ranch enjoyed games of croquet on the cottonwood-shaded grounds. They also looked forward to meals prepared by Jim, who was one of the first African Americans in Scottsdale. The ranch continued to operate through the 1950s. (Above, Scottsdale Historical Society; below, Scottsdale Public Library.)

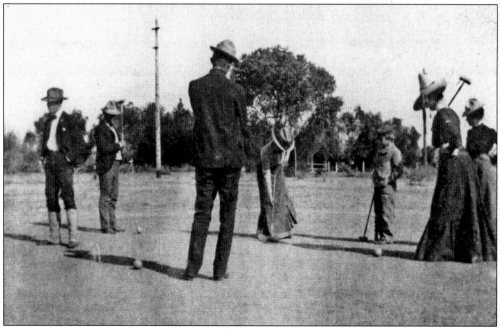

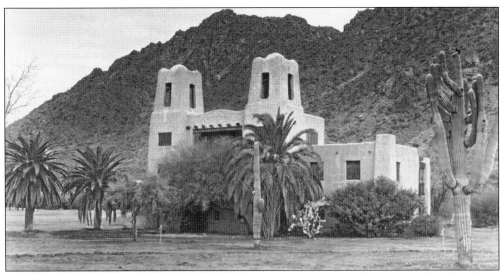

Sylvia and Bob Evans came to the Scottsdale area in the early 1920s for Bob's health. They built a home on the southeastern foot of Camelback Mountain near his mother, renowned artist Jessie Benton Evans. In 1926, Sylvia and friend Lucy Cuthbert opened a tearoom on the property, which proved so popular that they expanded to accept guests at their Jokake Inn for the winter season. Operating as a resort through the 1970s, Jokake Inn attracted movie stars, politicians, and the Frank Lloyd Wrights before they built Taliesin West. (Scottsdale Historical Society.)

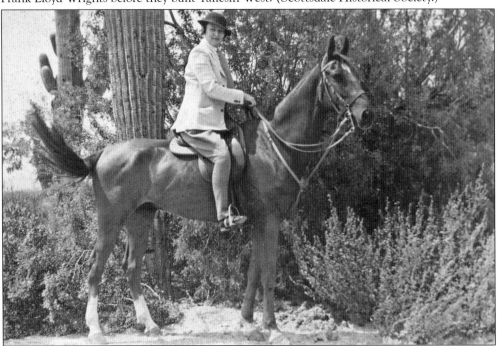

Sylvia Evans assured the popularity of Jokake Inn through delicious cooking (her devil's food cake was a favorite) and the inn's indigenous motif. Other early hotels in the Salt River Valley favored traditional Midwest or East Coast décor. Jokake Inn hired Native American and Mexican American artists and craftsmen to paint murals, design lighting fixtures, and provide pots and rugs, which intrigued guests. (Scottsdale Historical Society.)

R. T. "Bob" Evans was a talented architect and builder who designed the Jokake buildings and many others in the foothills of Camelback Mountain. His Southwestern designs using mud bricks earned him the nickname "Adobe Bob." During the 1930s, Evans donated the plans and equipment for construction of the Old Mission Church in Scottsdale. (Scottsdale Historical Society.)

Jessie Benton Evans was the grand dame of culture in the Salt River Valley from her arrival around 1913 to her death in 1954. The beautiful desert inspired many of her paintings, which she exhibited at local shows and nationally. She held salons in her home, Casa Del Deserto, inviting artists, musicians, and neighbors in for evenings of culture. Madame Evans also mentored young artists like Jesus Corral of Scottsdale, helping launch their careers. (Scottsdale Historical Society.)

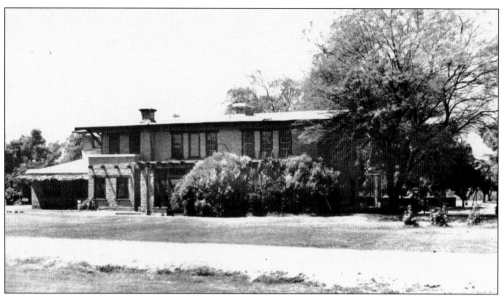

In the mid-1920s, Mildred Barthalow and Imogene Ireland opened The Adobe House Guest Ranch in what had been the Blount's house in the 1890s. Brochures advertised it as an old Spanish ranch house of thick adobe brick, with six comfortable guest rooms, spacious living rooms, a sunny dining room, and a separate Tower House, "An authentic replica of the church towers of old Mexico." (Scottsdale Historical Society.)

Unlike other area guest ranches, The Adobe House was not a health camp. During the 1920s and 1930s, it offered these unidentified guests "relaxation among orange and olive trees" as well as "several good golf courses within ten to twenty minutes' ride, saddle horses brought to the door each morning, desert picnics arranged as desired . . . and free garage space for guests' cars." (Scottsdale Historical Society.)

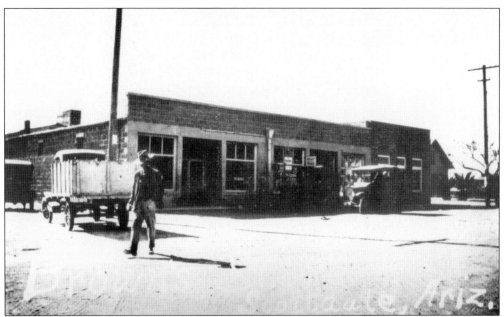

E. O. Brown's General Store on the southwest corner of Main Street and Brown Avenue (named in his honor) was the "see and be seen" place in the 1910s and 1920s. When the technology became available, Brown installed an evaporative cooler and added an ice plant to the store (right, at center as a large vented structure). In 1921, Brown and partners opened the Farmer's State Bank next door to his store (above, at the right end of the central building.) The bank also housed the town's first chamber of commerce and lending library. The intersection of Brown Avenue and Main Street was a hub for other businesses, including the Valley Super Service gas station, Johnny Rose's Pool Hall, and Lawson's Drug Store. (Above, Scottsdale Public Library; below, Scottsdale Historical Society.)

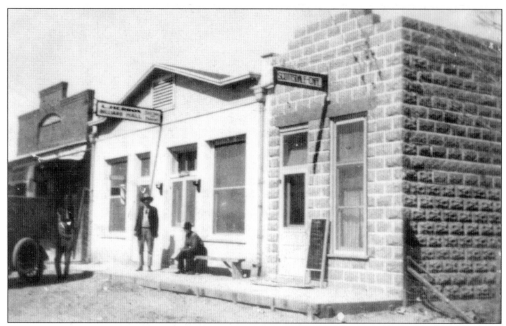

Herron and Walker Billiard Hall on the north side of Main Street, along with Johnny Rose's Pool Hall further down Main Street at Brown Avenue, provided entertainment for Scottsdale's males. Herron and Walker also housed a barbershop. Clara Boyer opened the Scottsdale Café in 1922. All establishments in Scottsdale were and remained "dry" until well after Prohibition was repealed in the early 1930s. (Scottsdale Historical Society.)

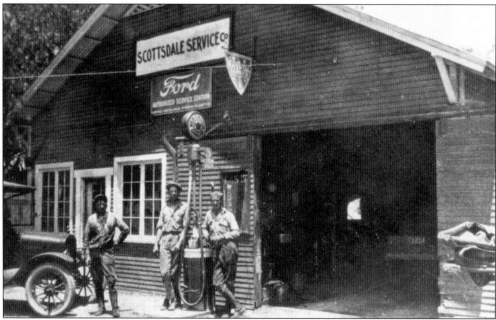

Automobiles began to replace horse and buggies in Scottsdale around 1912. One of the first to cater to cars was Mort Kimsey's Scottsdale Service Company on the northeast corner of Scottsdale Road and Main Street. Kimsey (center) and E. G. Scott (right), owner of a blacksmith shop, are pictured here in 1925 with an unidentified man. (Scottsdale Public Library.)

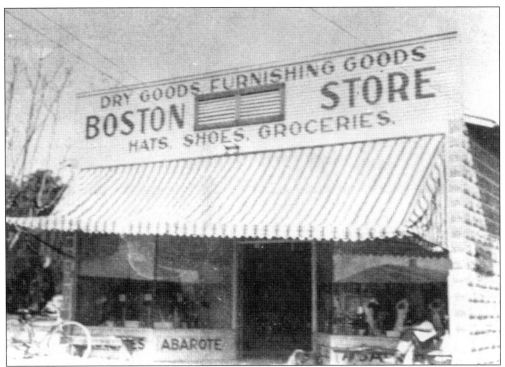

Lillian and Marshall Kubelsky, aunt and uncle of comedian Jack Benny, ran Kubelsky's mercantile during the 1920s, formerly called the Boston Store. Located on the north side of Main Street, the building later became Anderson's Market, the Saguaro Inn tavern, then Lulu Belle's restaurant in the 1950s. (Scottsdale Public Library.)

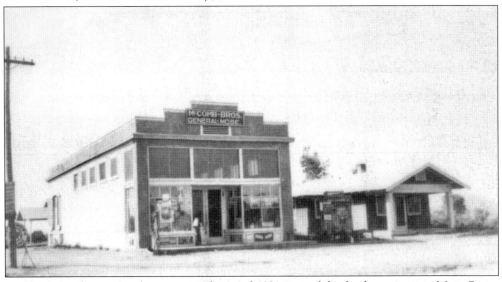

McComb Brothers general store opened around 1921, one of the few businesses on Main Street west of Scottsdale Road. In 1922, Byers Market opened across Main Street from McComb's. As a teenager, Earl Shipp worked for Byers before buying the store from his boss in the mid-1930s. Shipp renamed the store Earl's Market. While other grocers came and went, Shipp remained the town's popular grocer until retiring in the 1970s. (Scottsdale Public Library.)

George Cavalliere came to the Scottsdale area from California around 1909 to work on dredging the Arizona Canal. When the canal work was complete, "Cavie" and his wife, Mary Alice, moved their tin sled home and shop to Scottsdale, where he became the town's first blacksmith. In 1920, the Cavalliere's built a permanent adobe blacksmith shop (shown below), where family descendants were still producing ornamental ironwork in 2006. In its early years on the "edge of town," Cavie's hosted weekend boxing matches. Most resorts and posh homes built in the Scottsdale area included intricate ironwork designs created in the shop on Second Street and Brown Avenue. George Sr. and Mary Alice's children helped Scottsdale grow into a charismatic city, serving as town clerk, city councilman, restaurateur, artist, teacher, and businessman. (Scottsdale Public Library and George "Doc" Cavalliere Jr.)

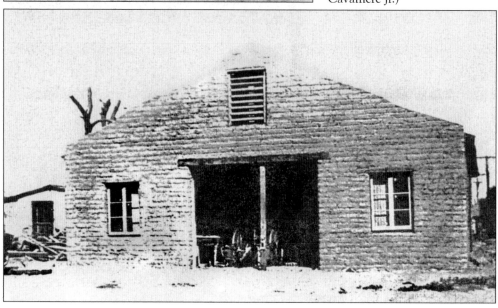

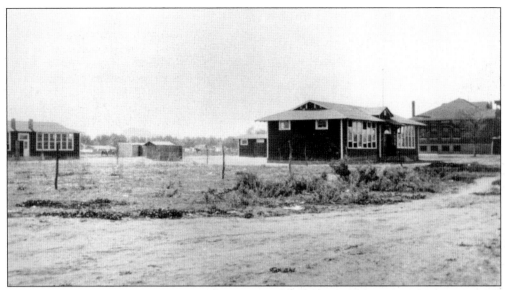

With the influx of workers for Scottsdale's cotton industry and general population growth, Scottsdale Grammar School was bursting at the seams. In 1918 and 1920, successful school bonds funded land purchases and construction of three wooden classroom buildings, which were built on the grounds of the Little Red Schoolhouse. (Scottsdale Public Library.)

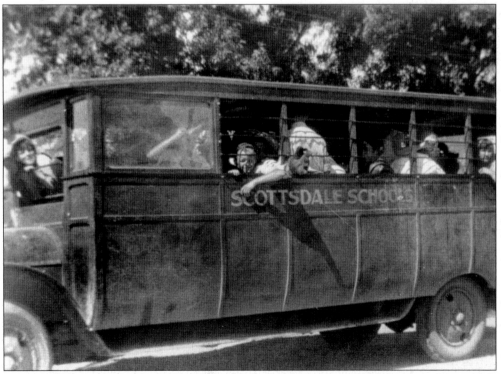

By 1923, there were enough children living beyond comfortable walking distance of Scottsdale Grammar School that the school board began providing free transportation to all pupils. The first bus was a Reo, costing $2,800, and was soon so busy that a second bus, a 1924 Ford, joined the fleet. (Scottsdale Public Library.)

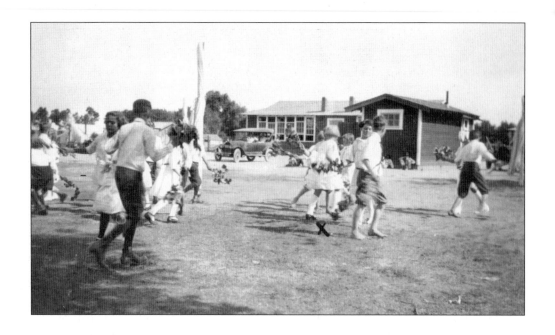

May Day was a highlight of the Scottsdale Grammar School year. Students would sing, dance, and wind tall maypoles for the Queen of the May. Eighth graders also presented a play before the end of the school year. School events were well attended by Scottsdale residents and held outdoors or in the school's small basement auditorium. The Scottsdale Parent-Teacher Association formed in 1917. The group served the school and also did Red Cross work, selling war savings stamps and sponsoring meat and flour substitution demonstrations, to serve the home front during World War I. (Above Scottsdale Public Library; below Scottsdale Historical Society.)

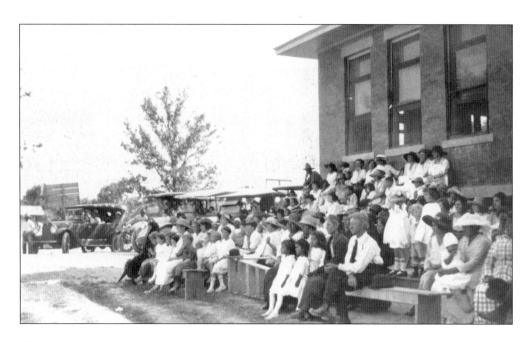

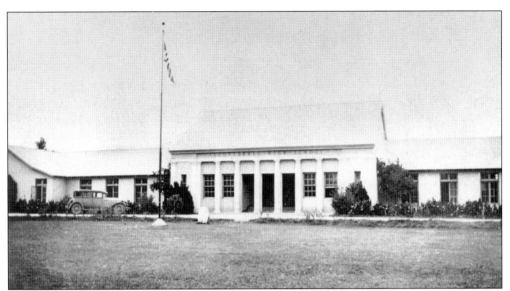

Although some high school classes had been offered in the Little Red Schoolhouse since 1916, by 1922 there were 49 high school-aged students who needed a school of their own. Another successful school bond election provided funds to construct Scottsdale High School on Charles Miller's land on the north side of Indian School Road east of Scottsdale Road. The building opened for the 1923–1924 school year with 50 students and L. O. DuRoss as principal. (Scottsdale Historical Society.)

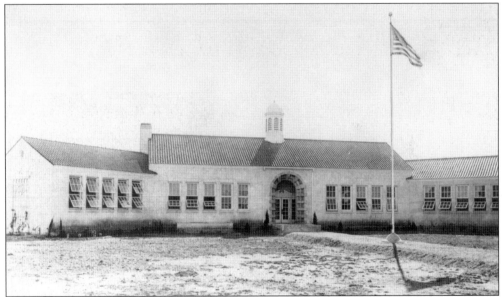

When Scottsdale High opened, the crowded conditions at Scottsdale Grammar School lessened. By 1928, however, the grammar school had 556 pupils and 14 teachers. Another successful bond election provided funds for a new school. Phoenix architects Lescher and Mahoney designed the Spanish Colonial Revival white stucco with a red-tile roof on the southwest corner of Second Street and Marshall Way. Principal Garland White opened the new Scottsdale Grammar School in September 1928. In 1954, it was renamed Loloma Elementary School. (Scottsdale Public Library.)

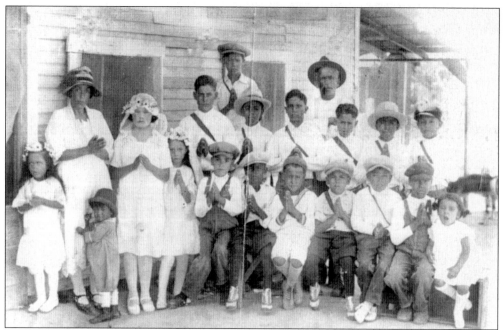

Religion played an important part in Scottsdale community life during the 1910s and 1920s. Scottsdale's Hispanic population comprised the town's first group of Catholics, who worshipped where they could until they built the Old Mission Church in 1933. The Herrera, Corral, Jauregui, and Valenzuela families celebrated important events together, such as this graduation from catechism school held in front of Bernabe Herrera's home. (Scottsdale Historical Society and Maria Jauregui Leyva.)

One of the first congregations to organize was the First Baptist Church of Scottsdale, which began meeting in the Little Red Schoolhouse in 1912. Under the direction of the Rev. Verner Vanderhoof, the congregation moved into this new church in 1918 on the southwest corner of Brown Avenue and Indian School Road. (First Baptist Church of Scottsdale.)

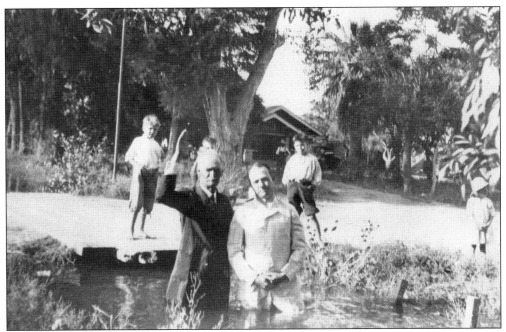

Scottsdale Baptists used canal ditches for baptizing as well as farm irrigation. Reverend Pope is seen here baptizing Fred Mathis in a ditch on a corner of Scottsdale and Indian School Roads. This ditch was the scene of many baptisms until the 1920s, when the congregation moved its ceremonies to a ditch along McDowell Road between Miller and Hayden Roads. (Scottsdale Historical Society.)

Although impossible for security and safety reasons today, in the 1910s and 1920s, Scottsdale's canals were popular swimming holes for children and adults alike. The canals also offered a place for fishing, hunting, canoeing, and, for the truly adventurous, riding a "surfboard" pulled by a Model T Ford along the canal bank. (Scottsdale Historical Society.)

Indiana's governor Thomas Marshall was married to Lois Kimsey, whose parents, William and Elizabeth, and brother Mort lived in Scottsdale. The Marshalls became regular visitors to Scottsdale in the 1910s, frequently staying at the Ingleside Inn. Marshall became Pres. Woodrow Wilson's vice president in 1914, giving the Marshall family visits to Scottsdale a special cachet. (Arizona Historical Society.)

U.S. vice president Thomas Marshall and his wife, Lois, built a winter home in Scottsdale across Indian School Road from Lois's parents, the Kimseys. It was the scene of political meetings, VIP visits, and a rare snowfall in the early 1920s. The home became a series of restaurants in the 1950s before burning down. (Scottsdale Public Library.)

Chinese immigrants opened several businesses in downtown Phoenix, and in 1928, Chinese immigrant Jew Chew Song opened a grocery store in Scottsdale in the former Johnny Rose's Pool Hall at Brown Avenue and Main Street. In 1950, family members converted the grocery into Mexican Imports, which was still operating as a Chew/Song family business in the historic glazed brick building in 2006. (Scottsdale Historical Society.)

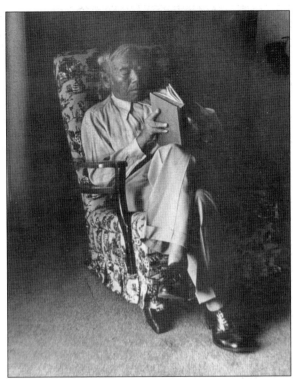

Several Scottsdale men served in World War I, and other World War I veterans chose to live in Scottsdale after their service ended. N. Carleton Lutes came to Scottsdale shortly after the war, became the town's first rural letter carrier, built a home north of Scottsdale on what would become Lincoln Drive east of Scottsdale Road, and was a founder of Scottsdale's American Legion Post 44 in 1935. (Scottsdale Historical Society.)

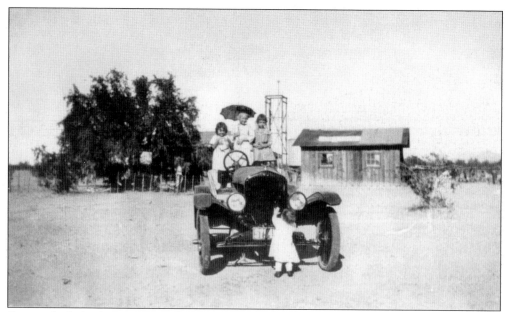

Despite the lack of access to canal water, some ranchers chose to move far north of the Scottsdale town site, toward and beyond the McDowell Mountains. Gabe Brooks established Powderhorn Ranch around 1917 on what is today Cactus Road. He was the Scottsdale area's chief water well driller for several decades. His "punch and judy" water-drilling rig is visible behind the car full of girls who were visiting Gabe's daughter Emmajeane. (Scottsdale Public Library.)

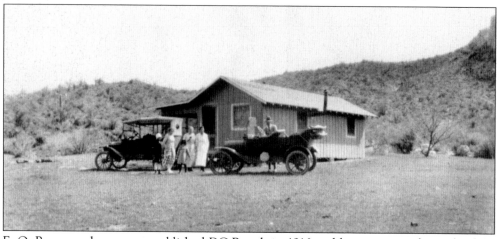

E. O. Brown and partners established DC Ranch in 1916 and began accumulating land for grazing cattle. The Lower Ranch, known as DC Ranch ("Dad's Camp" or "Desert Camp"), was headquartered east of Pima Road, south of Pinnacle Peak Road. It is now the location of a master-planned community by the same name, DC Ranch. (Scottsdale Public Library.)

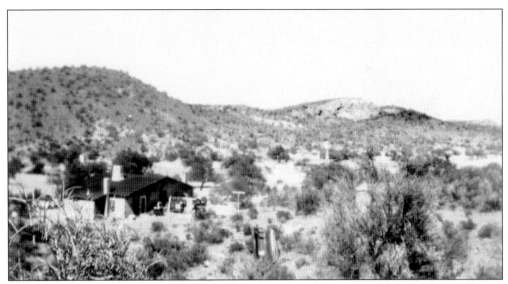

Browns Ranch, or the Upper Ranch, was a three-hour drive by car over the desert. Located north of Browns Mountain, a distinctive volcanic landmark, it was the northern extension of E. O. Brown and his partners' vast, 44,000-acre cattle ranch. While Brown spent much of his time in downtown Scottsdale tending to his other businesses, Gerbacio "Harvey" Noriega ran the ranch and was Scottsdale's quintessential cowboy. Brown's nephew George Thomas also had a key role in running the ranch, as did E. O.'s sons, Alvin and E. E. "Brownie" Brown. (Virgie Lutes Brown.)

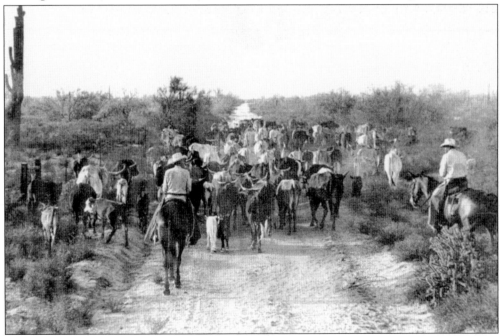

It took two days to herd cattle between Browns Ranch and the stockyards along Van Buren Road in Phoenix. Scottsdale men and their sons joined Browns Ranch hands for the twice annual cattle drive, stopping overnight with the herd at a way station near today's intersection of Shea Boulevard and the Loop 101/Pima Freeway. The ranch cook, "Chicken Henry," provided great roundup food, including delicious jerky gravy. (Scottsdale Historical Society.)

Farmers and ranchers south of the town site also considered Scottsdale their home. Among the farmers near McDowell and Scottsdale Roads were Lorene and Jacob Steiner. Jacob died at a young age, leaving Lorene with two small girls, Thelma and Labeula. She supported the family as a nurse for Tempe's Dr. Benjamin Moeur, later governor of Arizona. Thelma and Labeula and their families continued to serve Scottsdale for nine decades. (Southwest Studies, Scottsdale Community College, Marshall Trimble.)

A favorite sport in Scottsdale was hunting jackrabbits and quail, either by horseback or in a Model T Ford. One of the best spots for hunting was the "slough," an often-flooded, weedy area that eventually became one of Scottsdale's points of pride, the Indian Bend Wash Greenbelt Flood Control Project. (Scottsdale Public Library.)

Four

DEPRESSION AND WAR
SCOTTSDALE SHARES AND CARES
1931–1945

Scottsdale entered the Great Depression with an area population estimated to be 2,700. Like other Americans, some Scottsdale residents lost their farms and businesses to foreclosure, and others made use of the alphabet soup of federal New Deal programs. Since Scottsdale remained small and unincorporated, however, it did not have the political clout to attract major New Deal funding. Federal money did pay for extensions to Scottsdale Grammar School and Scottsdale High School. The Civilian Conservation Corps made improvements to nearby Papago Park, providing recreation for tourists and residents. Relief was distributed regularly from the Justice of the Peace Building on Main Street to those on "the dole." Everyone had a garden, shared what they grew, and many recycled hand-me-downs.

All was not doom and gloom during the Depression. Scottsdale's Hispanic community built a beautiful Spanish Colonial Revival–style church entirely through volunteer labor. Bob Evans built the Jokake School for Girls in 1933. Famed architect Frank Lloyd Wright established his winter home and school of architecture, Taliesin West, in the southern foothills of the McDowell Mountains. The Kiami Lodge and Camelback Inn opened. Scottsdale's art colony—Marjorie Thomas, Jessie Benton Evans, Lon Megargee, Oscar Strobel, Garnet Davy Grosse, Mathilde Shaefer Davis, Lew Davis, Lillian Wilhelm Smith, Jesus Corral, and others—kept producing for federal programs or wealthy patrons.

Those with foresight turned open desert into new living areas. George Ellis combined found materials like discarded redwood from canal flumes with adobe bricks to build homes north of Scottsdale in an area that became known as Cattle Track. The first non-cattlemen moved to the Pinnacle Peak area, including Phoenix lawyer K. T. Palmer and electric company worker Reg Phillips and their families. An entire community sprung up along Thomas Road near the Crosscut Canal when the Salt River Valley Water Users Association sponsored Yaqui Indians from Mexico to come to the area for long-term canal work. International Harvester president Fowler McCormick and his wife, Anne, bought a ranch north of town and began raising cattle and Arabian horses.

After Pearl Harbor, Scottsdale turned its attention to supporting the war effort. Thunderbird II Airfield opened north of town, employing many Scottsdale residents. Camp Papago interned Italian, then German, prisoners of war just west of Scottsdale. Federally funded Thunderbird Homes opened at Second Street and Marshall Way to help alleviate wartime housing shortages. Dozens of Scottsdale residents served in uniform. In 1943, Scottsdale was recognized for having the highest per capita sale of war bonds in the United States.

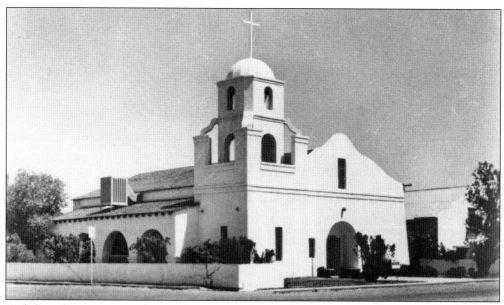

Built by volunteers using plans and equipment loaned by architect/builder Bob Evans, the Old Mission Church opened on Brown Avenue at First Street in 1933. Scottsdale's Hispanic and Yaqui Indian communities created its thousands of adobe bricks by hand. Bernabe Herrera made the stained-glass windows. Visiting priests conducted mass until 1949 when Fr. James Mulvihill was appointed the first resident pastor of Our Lady of Perpetual Help Church of Scottsdale. (Scottsdale Public Library.)

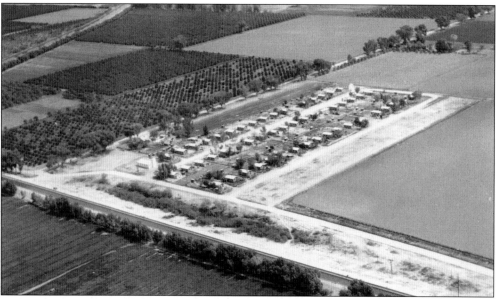

In the mid-1920s, the Salt River Valley Water Users Association sponsored Yaqui Indians and their families to emigrate from Mexico to work on area canals. The Water Users set up a work camp on 15 acres south of Thomas Road between Sixty-fourth Street and the Crosscut Canal. The first settlement was called Camp Viejo. In 1942, the Water Users built a new camp called North Side, seen here, that initially housed 230 people and included St. Philomena Catholic Church. (Salt River Project Research Archives.)

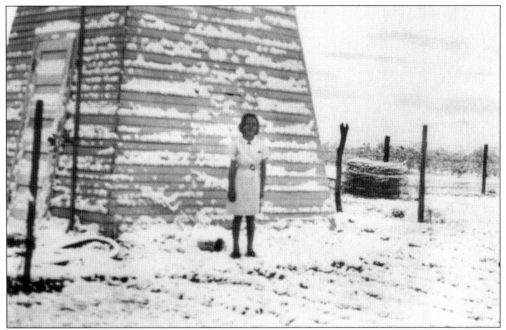

Carlton and Lucy Lutes built their family home on what would become Lincoln Drive east of the unpaved North Scottsdale Road. Daughter Virgie Lutes is seen here by the family's water tank during a rare snowfall in 1937. Virgie married E. O. Brown's son Alvin ("Cotton"), worked at Thunderbird II Airfield and managed Thunderbird Homes during the war, and then served as Scottsdale's first town clerk after incorporation in 1951. (Scottsdale Historical Society.)

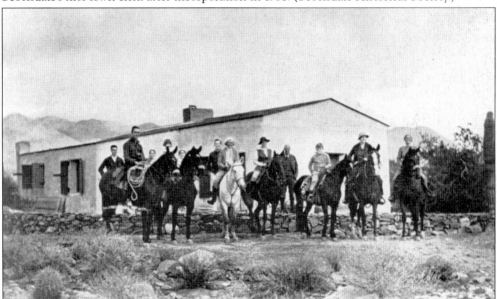

In 1933, Bob Evans built the Jokake School for Girls adjacent to the Jokake Inn. Girls from wealthy families throughout the United States traveled to the private school to take traditional courses as well as art, music, drama, dance, and horseback riding. Students and guests at the Jokake Inn would often ride their horses on a daylong trek to the Jokake Desert Camp, seen here, located on what is now East Shea Boulevard near Mayo Clinic. (Scottsdale Historical Society.)

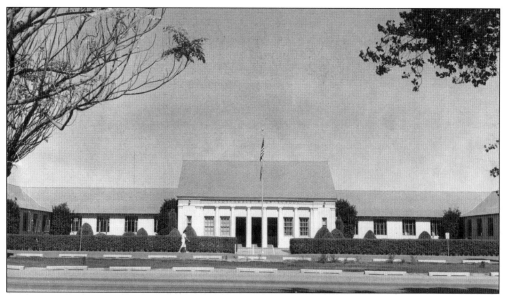

The New Deal's Public Works Administration provided funds to construct a wing on each side of Scottsdale High School's "Old Main" building, adding four classrooms. Five years earlier, another federal New Deal program funded additions to Scottsdale Grammar School. (Scottsdale Historical Society.)

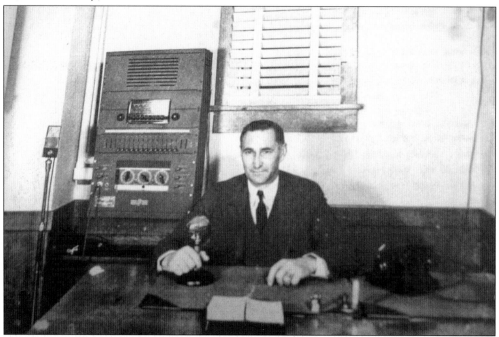

Scottsdale schools superintendent/principal Garland White demonstrates the state-of-the-art centralized sound equipment that was part of the 1938 Public Works Administration building program at Scottsdale High School. According to the 1939 *Camelback* yearbook, "The faculty and student body are enthusiastic in their praise, while Superintendent G.M. White considers it one of the best investments the school has made." (Scottsdale Historical Society, 1939 Scottsdale High School *Camelback*.)

Making the best of the Depression years, students at Scottsdale High School dressed up for dances and staged annual plays like *The Importance of Being Earnest* in 1931 and *Adam and Eve* in 1934. They played in the orchestra, debated in the Forensic League, and wrote for the *Beaver* newspaper. The school even had an Aviation Club, which future pilot and mayor Malcolm White joined in 1933. (Scottsdale Public Library.)

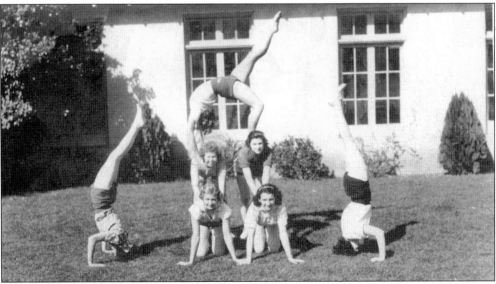

Outdoor sports and activities have always been important to residents. During the 1930s and 1940s, Scottsdale High School students participated in the Tennis Club, Camp Fire Girls, girls volleyball, and boys basketball, baseball, and football. Among the coeds shown here demonstrating their gymnastic skills is longtime Scottsdale resident and volunteer Labeula Steiner (Mowry), middle blonde in the three-girl stack. (Scottsdale Historical Society, 1936 Scottsdale High School *Camelback*.)

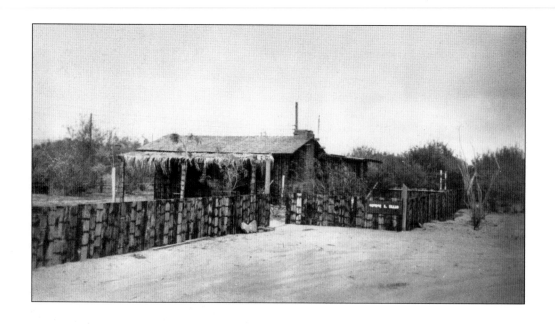

George Ellis was an entrepreneur, innovative designer, and builder who was "green" before environmental sensitivity was the buzzword of the building industry. In the mid-1930s, he began building homes, including one for his own family, north of Scottsdale near the Arizona Canal and an old cattle track. He used redwood recycled from abandoned canal flumes and handmade adobe bricks to fashion homes that attracted artists and other creative desert dwellers. The area became known as Cattle Track but was also called the Left Bank due to its canal location and the number of artists living there. Cattle Track earned a place on the National Register of Historic Places in the 1990s and is still operated as an artist enclave by Janie Ellis, George's daughter. (Above, Scottsdale Public Library; below, Ellis family.)

George Ellis, son David, daughter Janie, and wife Rachel attracted many creative people to their Cattle Track enclave north of the Scottsdale town site. During World War II, Thunderbird II Airfield manager John Swope and his actress wife, Dorothy McGuire, rented an adobe there. Artists Philip Curtis and Fritz Scholder lived there for many years. Valley real estate giant Russ Lyon and his family lived on the site in the late 1940s, followed by artist and gallery owner Avis Read and her family, just to name a few. (Ellis family.)

Duncan MacDonald collaborated with George Ellis on several of the homes in the Cattle Track area. He also built homes on the southern foothills of Camelback Mountain for wealthy newcomers, naming a street Invergordon for his ancestral home. McDonald Drive, although spelled differently, honors MacDonald. (Scottsdale Historical Society.)

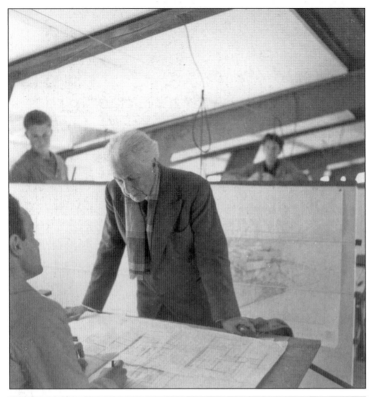

After several winters at the Jokake Inn, famed architect Frank Lloyd Wright and his wife, Olgivanna, established a winter home and Western location for his Wisconsin-based architectural school, Taliesin. Sited in the remote foothills of the southern McDowell Mountains, Taliesin West became a working laboratory for Wright to inspire his apprentices with his philosophy of organic architecture, weaving the surrounding environment into their designs. These 1940 images show Wright, top, in the Taliesin West drafting room and apprentices working outdoors. In the bottom photograph, John Lautner is in the left foreground; the other apprentices are unidentified. (Both Frank Lloyd Wright Foundation, Robert C. May photographs.)

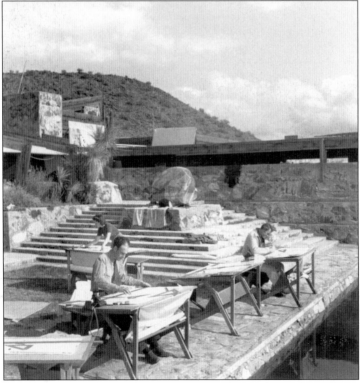

Industrialist John C. Lincoln and hotelier Jack Stewart built the Camelback Inn on the desert northwest of Scottsdale in 1936. Thanks to Stewart's range of contacts in the tourism industry and his promotional road trips, the inn was a seasonal success, bringing Scottsdale into the luxury travel limelight. Young Jack Kennedy, J. C. Penney, Mary Pickford, and Clark Gable were just a few who enjoyed visiting the newly nicknamed "Valley of the Sun" during the Camelback Inn's early years. (Scottsdale Public Library.)

Around 1937, the Kiami Lodge opened on Scottsdale Road a few miles north of town. Phoenix Indian School student artist Charles Loloma painted murals on many of the walls of the lodge and bungalows. A 1940s description in *Arizona Highways* said the adobe guesthouses featured large bedrooms with a dressing room and bath and were situated in a citrus grove at the edge of the desert. The lodge could accommodate 30 guests, November through May, and was still operating in the 1960s. (Scottsdale Public Library.)

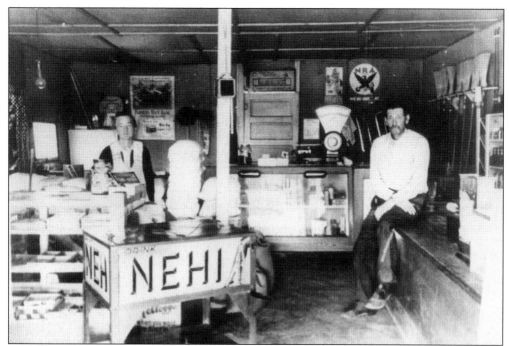

Merchants in downtown Scottsdale, located primarily on Main Street, Brown Avenue, or Scottsdale Road, did what they could to survive the hard times of the Depression. The owners of this unidentified market display the seal of the National Recovery Act on the right side of the back wall, demonstrating that they are adhering to new federal guidelines for hiring, work hours, and pricing. (Scottsdale Public Library.)

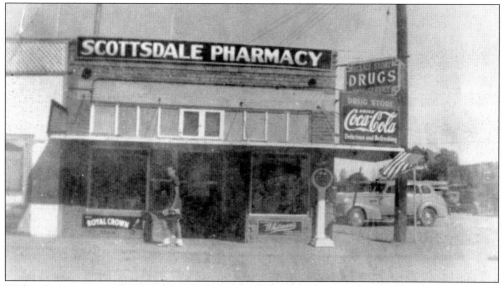

Walter Lawson opened Scottsdale's first drugstore on the northwest corner of Main Street and Brown Avenue in the 1920s called Sterling Drug. In 1937, it was renamed Scottsdale Pharmacy when William Butler took over. In 1948, the pharmacy moved to Scottsdale Road, and Lute Wasbotten became pharmacist/owner. The Saba family opened a Western wear store in the former pharmacy in 1948; Saba's was still operating in 2006. (Scottsdale Historical Society.)

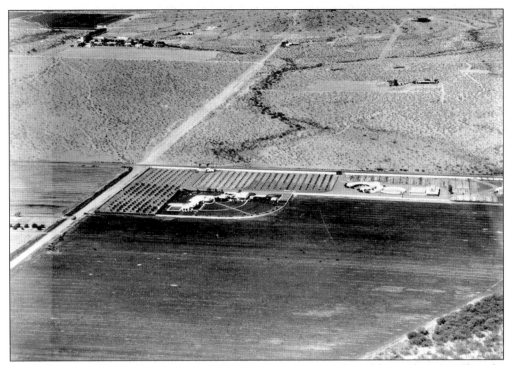

In 1942, International Harvester president Fowler McCormick and his wife, Anne, bought ranchland from Merle Cheney on Scottsdale Road (road seen left to right in center of photograph) at Indian Bend. They began raising Angus cattle and Arabian horses on their ranch, which eventually extended as far north as Shea Boulevard and east beyond Pima road. Anne was a patron of many artists in Scottsdale and cofounded the All Arabian Horse Show in the 1950s. (Scottsdale Historical Society.)

The slough, or Indian Bend Wash, frequently flooded, as seen here in 1939. When it was dry, it was a place for hunting and picnicking; when flooded, it cut Scottsdale in half, isolating residents who had no way to cross over the raging floodwaters. It was not until the 1970s that Scottsdale solved the problems of the slough, combining creative citizen input with the cooperation of the U.S. Army Corps of Engineers. (Salt River Project Research Archives.)

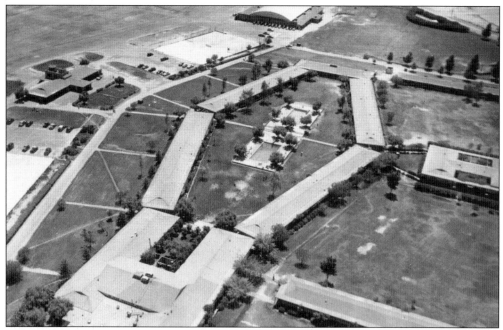

Hollywood luminaries, led by producer Leland Hayward, invested in Southwest Airways, a company set up to train pilots for World War II service at four airfields in the Phoenix area. In 1942, Southwest Airways opened Thunderbird II (T-2) Airfield in the vast desert north of Scottsdale. Artist Millard Sheets designed T-2 and its sister fields in Glendale and Mesa (another operated at Sky Harbor Airport). Hollywood photographer and pilot John Swope, who married actress Dorothy McGuire during the war, was T-2 Airfield manager. (Arizona Historical Foundation.)

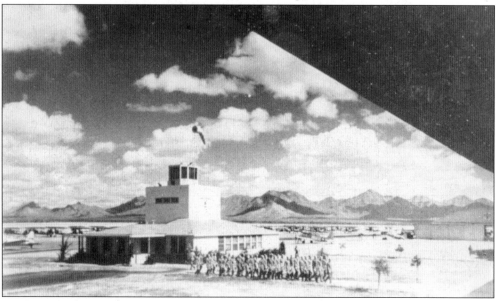

U.S. Army Air Corps aviation cadets came to Thunderbird II for primary flight instruction in Stearman bi-wing aircraft. They landed on an unpaved field, which was a muddy mess during summer rains. Pinnacle Peak provided a clearly visible navigational reference point for the new pilots to find their way back to the airfield. (City of Scottsdale.)

Except for a handful of U.S. Army Air Corps personnel, civilians operated Thunderbird II. Scottsdale High School graduate and businessman Malcolm White, second from the left in the back row, was a flight instructor. Dorothy Cavalliere Ketchum was a parachute rigger. Lucy Lutes was an aircraft mechanic, as were many men from the Salt River Pima-Maricopa Indian Community. The Adobe House's Mildred Barthalow cooked for the cadets and staff. (Scottsdale Historical Society.)

Five pilots graduated in the first class at Thunderbird II in 1942. After helping 5,500 aviation cadets earn their wings, the field closed in October 1944. Due to its Hollywood connections, stars and starlets often visited the cadets for a wartime morale boost. On the first anniversary of the field, T-2 held a rare open house for Scottsdale residents, who turned out in droves to see the otherwise off-limits airfield. (Scottsdale Historical Society.)

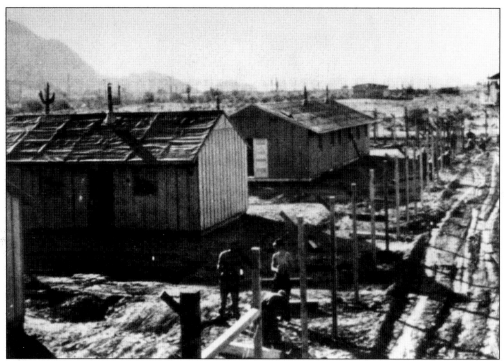

In 1943, the U.S. Army opened Camp Papago to intern Italian, then German, prisoners of war. Today Scottsdale's Sixty-fourth Street cuts through the former camp, bounded to the north by Thomas Road and extending south to McDowell Road. In December 1944, 25 German prisoners escaped through a 400-foot tunnel, which opened on the Scottsdale side of the camp fence. It took three months to round up the escapees and return them to camp. (Southwest Studies, Scottsdale Community College, Marshall Trimble.)

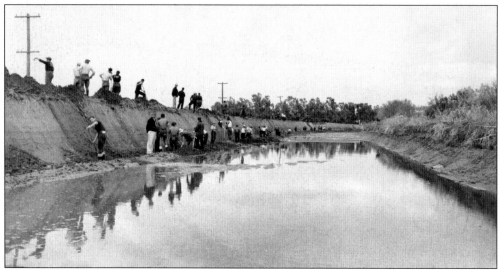

With so many men away from Scottsdale serving in World War II, area farms and companies had severe labor shortages. When possible, prisoners of war from Camp Papago in Papago Park were used to pick cotton and work on canals. This view shows Italian prisoners working on the Arizona Canal in 1943. (Salt River Project Research Archives.)

The federal government financed a public housing project for war workers and military families in Scottsdale on the northwest corner of Second Street and Marshall Way in 1943. Thunderbird Homes was comprised of one-story apartment buildings and a recreation center. After the war, many Scottsdale veterans and their families lived there until the buildings were auctioned off in 1960, and the land became a parking lot. The Loloma Transit Center now occupies the site. (Scottsdale Historical Society.)

American Legion Post 44 was established in 1935, however, after the war it took the name Sipe-Peterson to honor two of Scottsdale's war casualties, Travis Sipe and Clayton Peterson. As seen here, the post built a new facility on First Street in 1949. When the Veterans of Foreign Wars organized its Scottsdale Post 3513 in 1946, its members honored another Scottsdale son killed in the war, Stanley Crews, by adopting his name for their post. (Scottsdale Historical Society.)

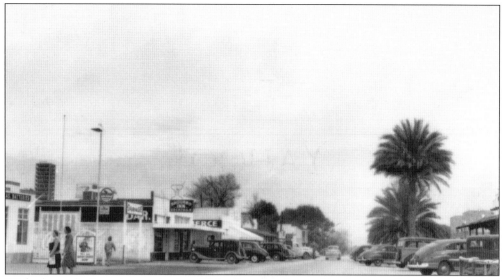

With the end of wartime rationing, Main Street welcomed back car traffic, customers, and new businesses. After many decades as a dry town, Main Street now boasted at least two bars, the Saguaro Inn (left center) and the Ping Bell, soon to be called the Pink Pony. (Scottsdale Public Library.)

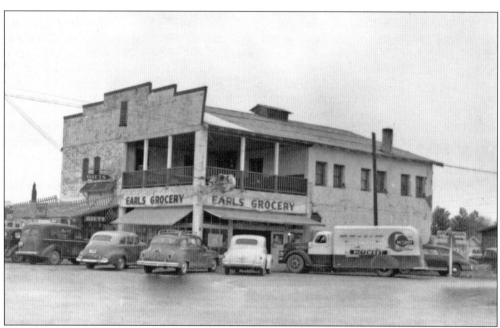

Although it took months for all the wartime restrictions to end, Scottsdale merchants geared up for the peacetime economy. The Picket Fence Gift Shop opened on the West Main Street side of Earl's Grocery, one of several new businesses to open in 1945. Veterans returned home, and many service people who had trained or been stationed in or near Scottsdale moved their families here after the war, providing great demand for goods and services. (Scottsdale Public Library.)

Five

YAHOO!
CREATING THE WEST'S MOST WESTERN TOWN 1946–1960

During the first full year of peace, Scottsdale was a place of unlimited opportunities. Visionary merchants and entrepreneurs saw potential to turn this farm town into a haven for tourists, artists, businesses, and new residents. Artists and craftspeople were one of the first groups to organize. With the patronage of businessman Tom Darlington, they turned the former Brown's General Store into an experiential Arizona Craftsmen Center.

The Scottsdale Chamber of Chamber reorganized in 1947, serving as an informal town government to get a few streets paved, street signs erected, and to begin a tourism advertising campaign. They also conjured up a slogan for Scottsdale—The West's Most Western Town—that they hoped would convey a spirit of Western adventure to visitors and residents. Following the theme, merchants voluntarily redesigned their storefronts in Western motif—board and batten with hitching posts and shake roof overhangs. National media gave this Western image plenty of ink, which helped lure more tourists and residents.

In 1949, the chamber began to hold hearings to gauge public sentiment on whether it was finally time to incorporate Scottsdale. After a successful petition drive in early 1951, the Maricopa County Board of Supervisors declared Scottsdale an incorporated town on June 25, 1951—with a population of 2,037 living on less than one square mile of the downtown area.

Guest ranches opened throughout the Scottsdale area, with colorful Western names like Yellow Boot, Bunkhouse, Paradise Valley, Sundown, and Rancho Vista Bonita. Car-friendly, year-round resort hotels followed the guest ranches, with the Hotel Valley Ho and the Safari Hotel opening in late 1956. Community organizations staged special events to draw tourists and entertain residents: the Sunshine Festival (renamed Parada Del Sol), All Arabian Horse Show, spring training baseball, and rodeos.

Cotton, alfalfa, and grazing fields became a sea of rooftops. When Motorola opened facilities in and near Scottsdale, hundreds of new residents moved to town. All these new families and the postwar baby boom demanded an aggressive building program for the Scottsdale School District. Nine new elementary schools opened, most given Native American names, between 1954 and 1959, with many more to come. The new town government began establishing fire protection, police service, water and sewer service, and zoning guidelines, and annexed land in all directions in order to control Scottsdale's character and destiny. New civic groups took on the role of establishing recreational, health, and charitable programs for the town.

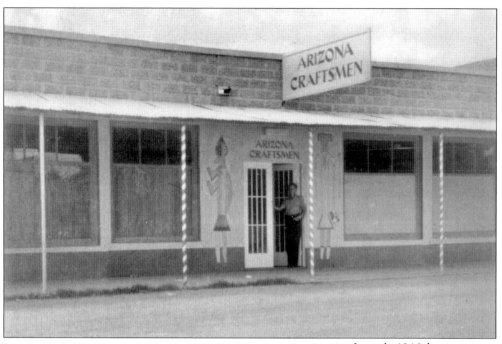

In early 1946, businessman Tom Darlington opened the Arizona Craftsmen Center in the former Brown's Store at Brown Avenue and Main Street in downtown Scottsdale. Silversmith Wes Segner (above, in doorway), leather fashion designer Lloyd Kiva, woodcarver Phillips Sanderson, painter Lew Davis, sculptress/potter Mathilde Schaefer Davis, and calligrapher/photographer Leonard Yuschik engaged in their craft while visitors watched, then likely purchased. The concept worked, drawing tourists, residents, and former First Lady Eleanor Roosevelt (left), who mentioned the new art center in her nationally syndicated "My Day" column. (Both Scottsdale Area Chamber of Commerce, Wesley Segner photographs.)

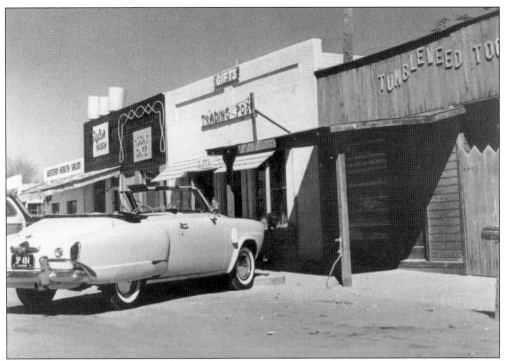

Buck and Leo Sanders opened the Trading Post gallery and art supply shop on Brown Avenue in 1949. In 1950, they introduced a little known Tucson artist to Scottsdale, Ted DeGrazia. He became a frequent exhibitor in Scottsdale, where his watercolors of stylized Native American children and Arizona scenes became a must-have souvenir. Native American artist Pop Chalee also drew crowds to the Trading Post in the early 1950s. (Scottsdale Historical Society.)

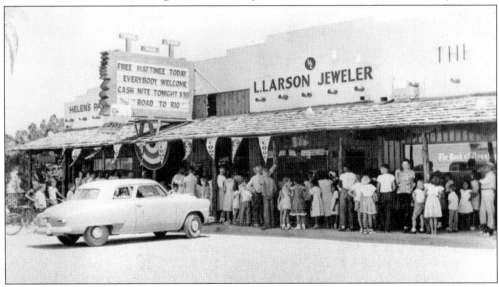

When Malcolm White opened the Tee Bar Tee on the south side of Main Street in 1948, Scottsdale finally had its own movie theater. It featured a crying room for babies and a smoke bar. In 1955, White opened the town's first drive-in movie, The Round-up, on Thomas Road west of Scottsdale Road. (Scottsdale Historical Society.)

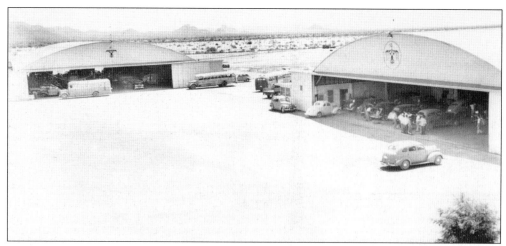

In 1947, Arizona State College acquired Thunderbird II Airfield from the War Assets Administration and moved its Vocational Training Program from Mill Avenue to the 720-acre site and its 33 buildings. Veterans used their GI Bill education benefits to attend classes that were designed to meet the demands of the new peacetime, consumer economy. The college held dances and intercollegiate rodeos there, too. (Arizona State University Libraries, ASU Archives.)

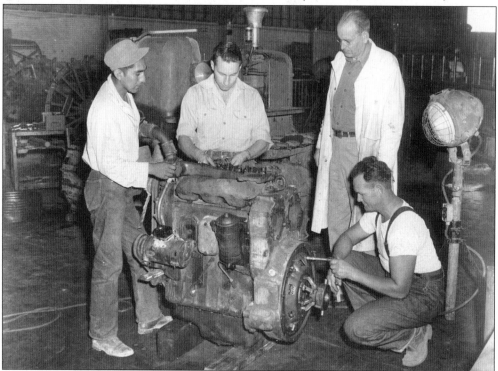

Veterans and other students in Arizona State College vocational training classes at the former Thunderbird II Airfield studied auto mechanics and electrics, auto upholstery, diesel and heavy equipment repair, car painting and body and fender work, refrigeration and air conditioning, welding, farm shop training, and furniture upholstery and repair. After five years and declining enrollment, Arizona State closed the school and turned the property back to the government. (Arizona State University Libraries, ASU Archives.)

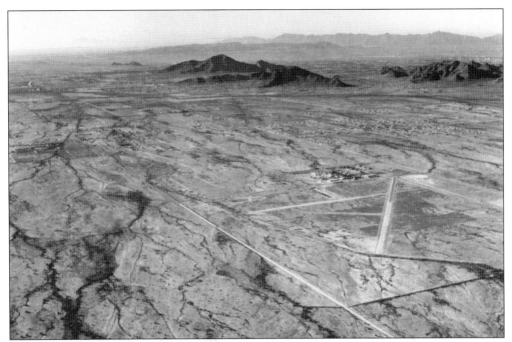

As this postwar photograph shows, Thunderbird II Airfield was surrounded by vacant land. Scottsdale began to grow—with new residents moving in and the town annexing land in all directions. The town's economic engine changed during the 1950s from agriculture to a mix of tourism, business, and construction of new homes and businesses. By 1970, development had reached the former airfield. (Scottsdale Area Chamber of Commerce.)

Into the 1950s, Scottsdale High School still offered agricultural classes, and students participated in the 4-H Club. By the 1960s, the number of family farms and ranches dwindled rapidly in Scottsdale and other Valley of the Sun communities. (Scottsdale Historical Society, 1952 Scottsdale High School *Camelback*.)

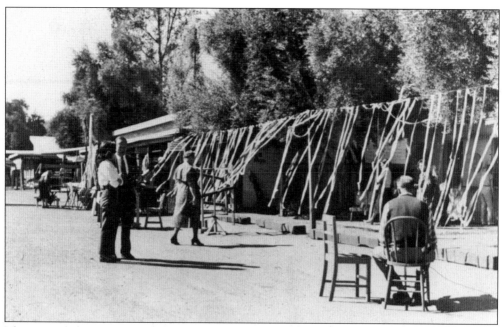

The original Arizona Craftsmen Center at Brown Avenue and Main Street burned down in 1950. Arts patron Anne McCormick helped the artists rebuild in a previously undeveloped area west of Scottsdale Road and south of the Arizona Canal. Since many of the craftspeople were producing wearable art, jewelry, and fashions, it was appropriate that the new area was called Fifth Avenue. Wes Segner (in chair at right) and Lloyd Kiva were joined in the new Arizona Craftsmen Center by silk-screener Leona Caldwell, goldsmith Alexander Kowal, Erne the custom perfumer, and others. (Scottsdale Historical Society.)

As arts, crafts, and fashion business along Fifth Avenue increased, leather and silk-screen fashion genius Lloyd Kiva (third from left) built the Kiva Craft Center on the south side of Fifth Avenue. Among his first tenants were Charles Loloma (far left) and his wife, Otellie (far right), who were skilled pottery sculptors. Charles turned his talents to making Hopi-inspired, world-renowned jewelry. (Scottsdale Historical Society.)

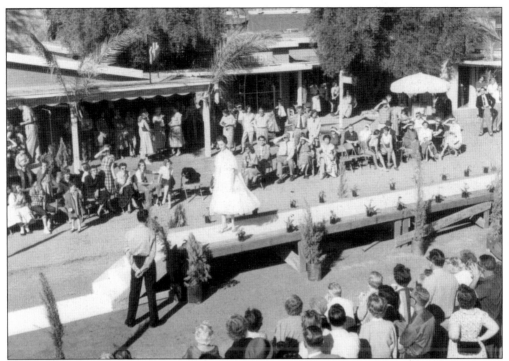

Throughout the winter tourist season, the fashion houses along Fifth Avenue sponsored fashion shows, often right down the center of the street, like this 1957 event. Other shows took place around resort hotel pools. Lloyd Kiva, as skilled in promotion as he was at fashion design, was usually the organizer and commentator for the shows, which often featured area celebrities, like actress Acquanetta. (Scottsdale Historical Society.)

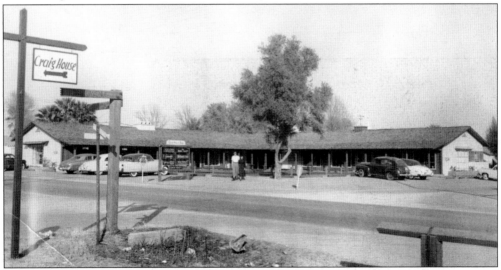

Scottsdale gained a reputation as a fashion center during the 1950s. When Goldwater's opened in Scottsdale's new Ranch House Shops on the northeast corner of Scottsdale Road and First Avenue in 1950, they, too, sponsored fashion shows. One dazzling event staged on Main Street, "Sunset Pink," featured *Harper's Bazaar* models wearing all pink couture. *Life* magazine twice featured Scottsdale's "homegrown" fashions. (Phil Schneider.)

Watching artists and craftspeople at work and learning more about art was so popular during the 1950s that cultural enclaves popped up all over Scottsdale and its environs. Joyce and Wes Segner opened Craft Village on Miller Road in the late 1950s. Artists Bill Schimmel, Tom Daley, and glazier Joseph Maes were among the tenants at the Segner's demonstration studio and art school. (Scottsdale Public Library.)

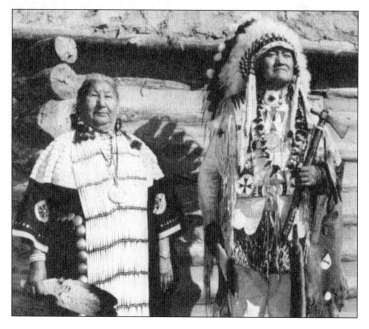

Anne McCormick had long collected Native American art and crafts. In February 1954, she had several hogans built in the central part of McCormick Ranch to house the Indian Arts and Crafts Center. Chief Wets and his wife are seen here at the center. Artist Pop Chalee and her husband, Ed Natay, an artist and musician, were also seasonal favorites of center patrons. (Mae Sue Talley, publisher of *The Arizonian*.)

Avis Read arrived in Scottsdale in 1950 and moved her family into a ranch house in the Cattle Track area north of McDonald Drive at the Arizona Canal. A talented artist, she opened up the Stable Gallery, which featured promising as well as established artists, art classes, and weekly special events throughout the winter season. She is seen here, second from left, with one of many cultural groups who came to the gallery. (Scottsdale Historical Society.)

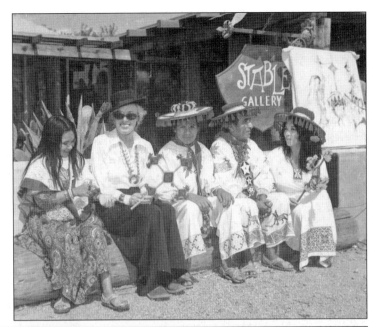

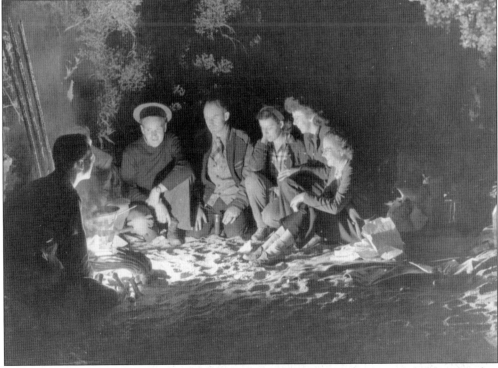

The presence of so many creative types in Scottsdale gave the town a special character. Rather than isolating themselves in pursuit of their art, Scottsdale's artists and craftspeople imbibed with the regulars at the Pink Pony and helped start the chamber of commerce. This scene from the late 1940s is a cookout in the open desert at Scottsdale and Camelback Roads, attended by, from left to right, Leonard Yuschik, Wes Segner, Frank "Hoot" Gibson, Betty New (Lloyd Kiva's wife), Joyce Segner, and Eleanor Gibson. (Scottsdale Historical Society.)

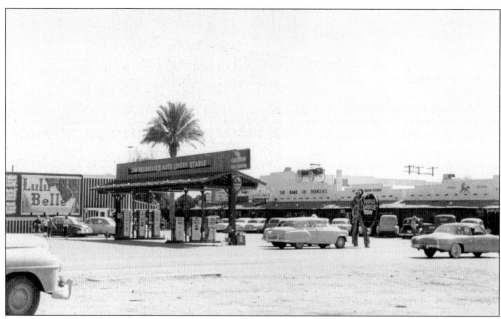

Merchant Malcolm White and other members of the newly formed chamber of commerce adopted the slogan, "West's Most Western Town" to use in marketing Scottsdale *c.* 1947. Without the presence of municipal design standards in yet-to-be incorporated Scottsdale, new and existing businesses voluntarily conformed to a Western motif throughout the expanding downtown area. Gas stations became "auto livery stables," and bits of Western décor—from board and batten facades to buggies and hitching posts—became the norm. Even chain stores like Woolworth's (below) designed its new building, this one on the northwest corner of Scottsdale Road and Main Street where's Earl's Grocery had been, in Western motif. (Both Scottsdale Historical Society.)

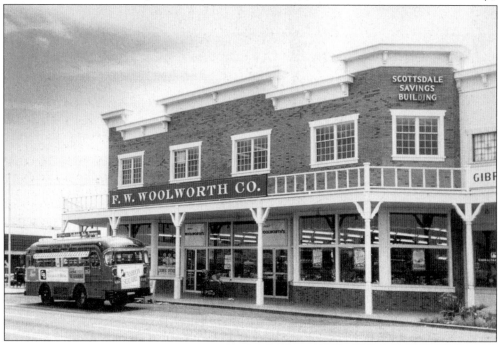

Following the Western theme, the Scottsdale Chamber of Commerce erected a Masonite® cowboy signboard in 1952 on the northeast corner of Scottsdale Road and Main Street to welcome folks to town and tell them what event might be taking place. Designed by local woodcrafter Dee Flagg, it became Scottsdale's place to be photographed. The sign was still standing in 2006 after several face lifts. (Scottsdale Area Chamber of Commerce.)

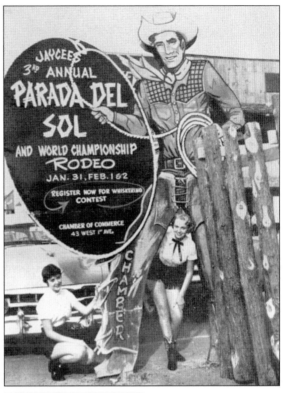

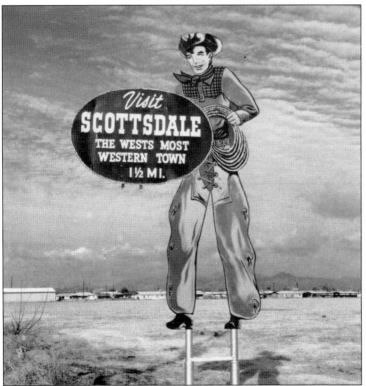

The cowboy sign at Scottsdale Road and Main Street had kin at various points leading into Scottsdale. An August 1956 front-page article in the *Scottsdale Progress* reported that agreements had been signed with advertisers for 15 replicas or near-replicas of the cowboy sign to be placed along main highways within a 60-mile radius leading into the Valley of the Sun and Scottsdale. (Scottsdale Historical Society.)

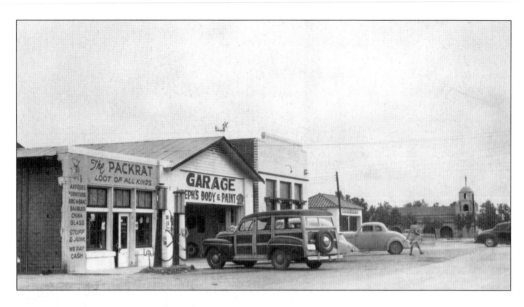

Once Scottsdale incorporated in 1951, downtown streets finally were paved and dust was no longer a major problem. Dusty or paved, the street conditions didn't stop businesses from opening up, as these two photographs of Brown Avenue taken in 1947 and 1955 depict. Scottsdale got its first permanent newspaper when the *Scottsdale Progress* (bottom photograph, center) began publishing in May 1947. The gas and electric company CALAPCO, now Arizona Public Service, located a branch on Brown Avenue, managed by Mort Kimsey. Chew's grocery (center of top photograph, with a blank white facade) became Mexican Imports in the early 1950s, which is still run by the Chew/Song family in the 21st century. The Packrat was one of many shops opened in the late 1940s to feed consumers' postwar buying sprees. (Both Scottsdale Public Library.)

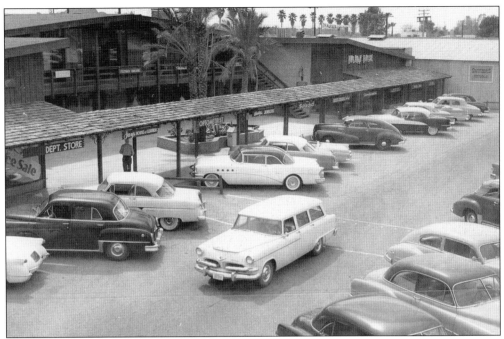

Hastily opening new businesses after World War II, merchants recycled old downtown buildings to meet their needs, like converting Lottie Sidell's guest cottages on Main Street into the Village Patio Shops. Scottsdale got its first planned shopping area when several businessmen—Paul Feltman, Bill Weirich, and others—hired Ralph Haver to design a car-friendly shopping street. Pima Plaza (above) opened on First Avenue around 1953. (Scottsdale Historical Society.)

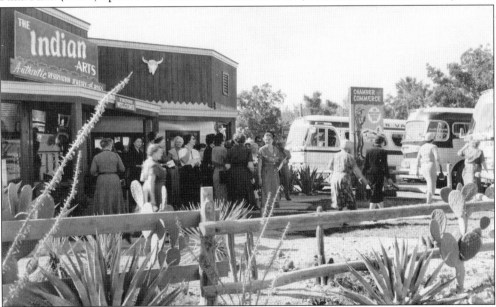

The Scottsdale Chamber of Commerce located its offices in the Indian Arts Building at Pima Plaza in 1954. Visiting convention groups, like this gathering of the National Association of Bank Women in October 1955, came by the busload to be welcomed by the chamber and shown the shops and galleries through downtown. (Scottsdale Historical Society.)

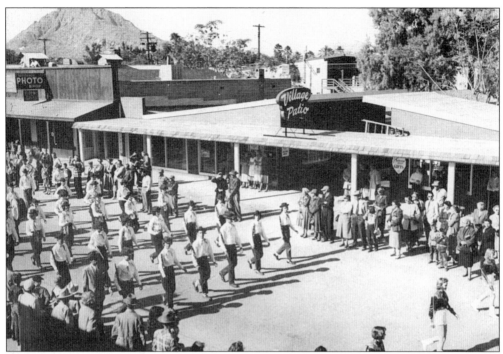

To kick off the 1951–1952 tourist season, the Scottsdale Chamber of Commerce sponsored the first annual Sunshine Festival. Held in November, it featured a parade and community picnic. It became an annual tradition, with the Scottsdale High School Beaver Band (here in 1953), horse-drawn wagons, and horseback riders in full Western regalia parading down Main Street. (Scottsdale Historical Society, 1954 Scottsdale High School *Camelback*.)

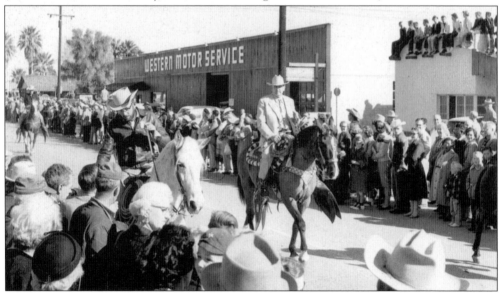

In 1954, the newly formed Scottsdale Jaycees took over the Sunshine Festival, moved it to a midwinter date, and changed its name to the Parada Del Sol, or "walk in the sun." Browns Ranch honcho, E. E. "Brownie" Brown (center on horse), was grand marshal of the 1956 Parada. That year, the Jaycees added a rodeo to the annual parade and barbeque. (Scottsdale Historical Society.)

Florence and Harold Daugherty, riding Arabians Skorage and Donita from Ed Tweed's BruSally Ranch, were regulars in the Parada Del Sol parade. Each year the number of equestrian units increased, making Parada the longest horse-drawn parade in the world. (Arizona Transplant House.)

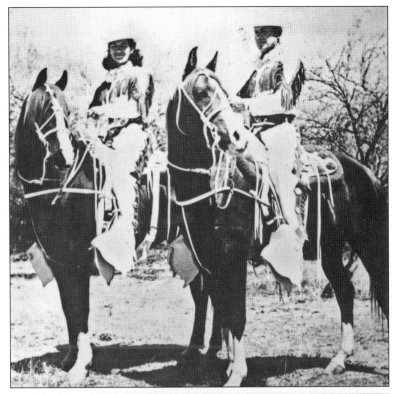

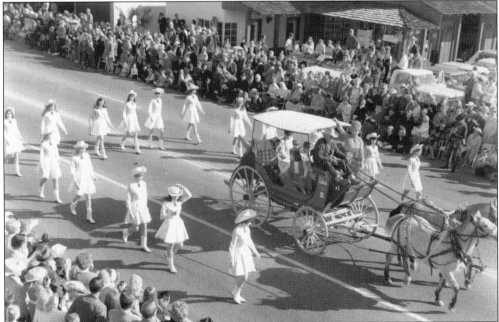

Local resident Amanda Blake, who played the role of Miss Kitty in the popular *Gunsmoke* television show, waves from a wagon in the Parada Del Sol parade. She is escorted by the Howdy Dudettes, a group of high school coeds who served as junior ambassadors for the Scottsdale Chamber of Commerce for over two decades. (Scottsdale Historical Society.)

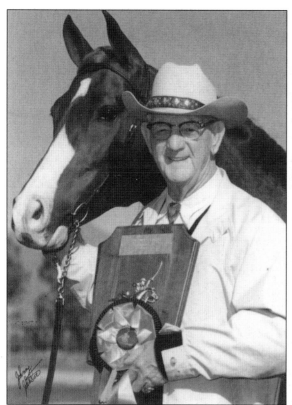

During the 1940s, several ranches north of Scottsdale began raising Arabian horses; the Cheneys and McCormicks were among the first. In 1950, Ed and Ruth Tweed built BruSally (honoring their children Bruce and Sally) Ranch on Hayden Road between Shea Boulevard and Cactus Road. Tweed imported prized stallions from Poland and produced many award-winning Arabians, like Orzel, seen here with Tweed (left). BruSally and other ranches sent Arabians to shows and sales throughout the country, boosting the stature of Scottsdale's Arabian industry. Tweed organized the first Arabian Horse Auction in Scottsdale, served as the first president of the Arabian Horse Association of Arizona, and helped start the All Arabian Horse Show. In the 1990s, his family turned BruSally Ranch (below) over to the Arizona Transplant House, which opened it as a homey facility in which organ transplant patients recover. (Both Arizona Transplant House.)

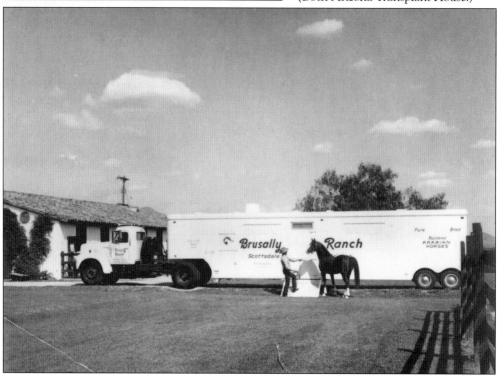

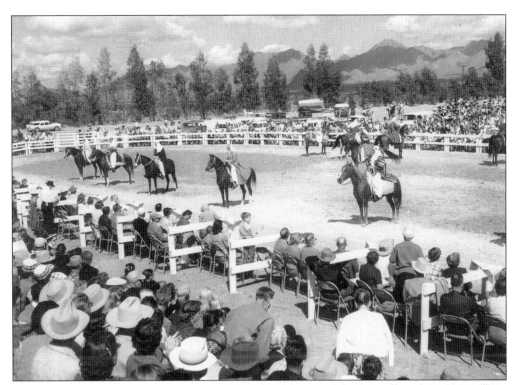

Anne McCormick, Ed Tweed, and the F. K. Wrigleys sponsored the first All Arabian Horse Show in Scottsdale in February 1955. For many years, the show took place at Paradise Park, seen here, which was an arena Mrs. McCormick built on the northernmost part of the vast McCormick Ranch. The All Arabian Horse Show has grown to include riding exhibitions, horse and tack sales, and networking among Arabian owners and admirers. In 1987, the show moved to Scottsdale's then-new WestWorld equestrian facility. (Scottsdale Historical Society.)

The graphic design might be overly simple by today's standards, but the first ads created by the Scottsdale Chamber of Commerce in the early 1950s produced results. In no time, "The West's Most Western Town" was known as a showplace, resort capital, fashion center, arts and crafts center, and fast-growing city. (Scottsdale Area Chamber of Commerce.)

In 1955, the Phoenix Thunderbirds brought their annual Phoenix Open Golf Tournament to the Scottsdale area, holding it every other year at the Arizona Country Club, which opened after the war on the site of the former Ingleside Inn golf course. The all-volunteer Thunderbirds, comprised of valley businessmen, included Gov. Paul Fannin (below, in cart) and Sen. Barry Goldwater (below, standing). Scottsdale residents were part of "Arnie's Army," following golf superstar Arnold Palmer around the course during his wins there in 1961, 1962, and 1963. The event also brought celebrities to Scottsdale to play in the Professional-Amateur (Pro-Am) event. (Left, Mae Sue Talley, publisher of *The Arizonian*; below, Arizona Historical Society .)

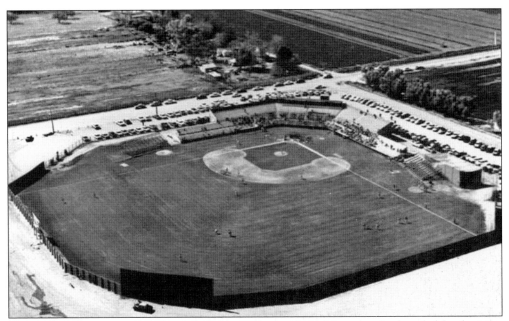

Scottsdale businessmen Bill Weirich, Roland Feltman, Jack Adams, and others led fund-raising to build a baseball stadium in Scottsdale in order to host a major-league organization for spring training. The Baltimore Orioles were the first team to hold their spring games in the stadium when it opened in February 1956 on the northeast corner of Osborn Road and Ballpark Drive (above). After three years, the Orioles moved back to Florida's Grapefruit League, and the Boston Red Sox—including star Ted Williams—moved into Scottsdale's stadium, resorts, and restaurants during their month-long spring training. (Above, City of Scottsdale, Scottsdale Charros; below, Scottsdale Historical Society.)

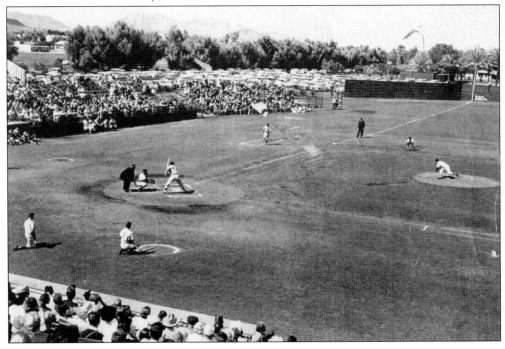

Starting as a religious ceremony honoring the Virgin of Guadalupe, the Our Lady of Perpetual Help Church-Scottsdale event grew into a community-wide Miracle of the Roses Pageant in the early 1950s. Each December, residents would decorate the streets and Old Mission Church; artists and writers like Paul Coze, Jesus Corral, Collice Portnoff, and Patricia Benton Evans helped with the staging. Valley winter resident and former ambassador Clare Booth Luce (left) donated a mosaic of Our Lady of Guadalupe for the event. Mariachis (below) provided music and town youth performed in the pageant's play. (Both Our Lady of Perpetual Help Church-Scottsdale.)

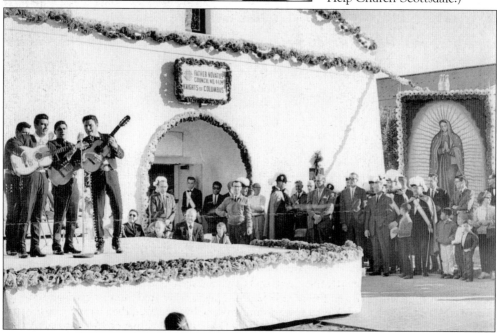

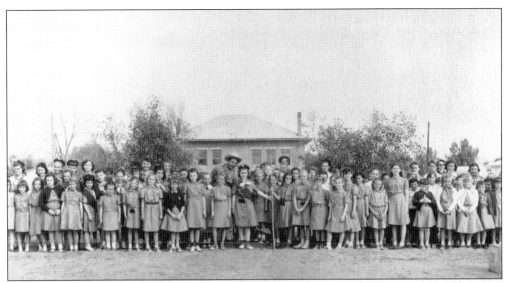

Scottsdale residents, adults and children, participated in a myriad of community-building and charitable events during the 1950s. In 1957, Scottsdale's first mayor, Malcolm White (center in cowboy hat), helped Scottsdale Girl Scouts plant trees, provided by the Scottsdale Jaycees, behind the Little Red Schoolhouse, which at the time served as Scottsdale's town hall. (Scottsdale Public Library.)

The Scottsdale Community Players were one of many civic, charitable, and cultural groups to form in the early 1950s. The little theatre group began its stage productions in the Scottsdale High School auditorium with *Life with Father* in 1952. The Players converted a former carriage house on the grounds of The Adobe House into a performing venue in the 1950s, then moved into the new Stagebrush Theatre on Second Street in 1967. (Mae Sue Talley, publisher of *The Arizonian*.)

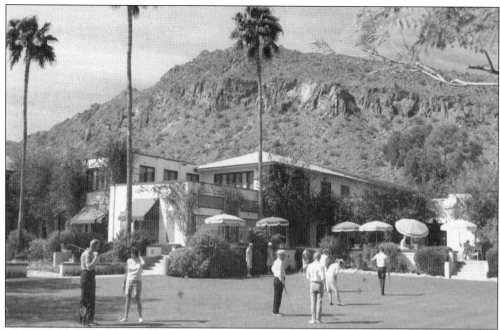

Several small resorts opened when World War II rationing ended and people could travel again. Bob Evans built the Paradise Inn and welcomed guests by 1946. Just east of the Jokake Inn, the Paradise Inn offered meals, relaxation, tennis, a putting green, and shared the Valley Country Club Golf Course with the Jokake Inn. It operated through the 1970s before being torn down to make way for The Phoenician resort. (Scottsdale Historical Society.)

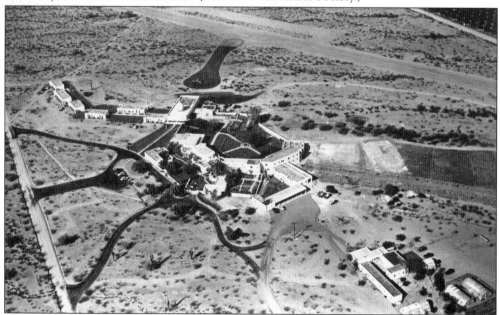

George Borg bought the sprawling home of the Donald Kellogg family north of Chaparral Road and west of Scottsdale Road and turned it into a retreat for Borg Warner Company executives, complete with its own landing strip (dirt strip at top). In 1946, it opened as the Casa Blanca Resort, adding a Moorish facade and dome. (Scottsdale Historical Society.)

84

In 1946, Elizabeth Arden converted an estate on the southern slope of Camelback Mountain into the exclusive Maine Chance spa, a favorite hideaway for rich and famous women such as Mamie Eisenhower, Clare Booth Luce, Ava Gardner, and others. Mrs. Eisenhower (above in center, and bottom) was a regular guest during her eight years as first lady and for many years afterwards. She brought along a contingent of Secret Service agents, had a favorite room, donned a pink robe for spa treatments, and attended many social and political events in Scottsdale and the valley. (Both Dwight D. Eisenhower Library.)

Small guest ranches offered their visitors an intimate setting and an authentic Western experience. Dorothy (center foreground) and Burke Patterson opened the Ride-n-Rock Ranch on Indian Bend Road near the McCormick's horse and cattle ranch in 1949. Their tourist season kickoff barbeque was a sought-after invitation for residents. Guests could ride a horse into the desert with the ranch hands, who would cook them breakfast over an open fire. Actor Fred MacMurray was a regular visitor. (Scottsdale Historical Society.)

The Ingleside Resort became Brownmoor School For Girls in 1945, leaving Scottsdale without a golf course. The Sundown Ranch Golf Course opened in December 1953, with weekday greens fees of $2. Sundown's guest ranch-style cottages accommodated 48 seasonal visitors. Located on Shea Boulevard just east of Scottsdale Road, the guest ranch and golf course became Scottsdale Country Club around 1960. (Scottsdale Historical Society.)

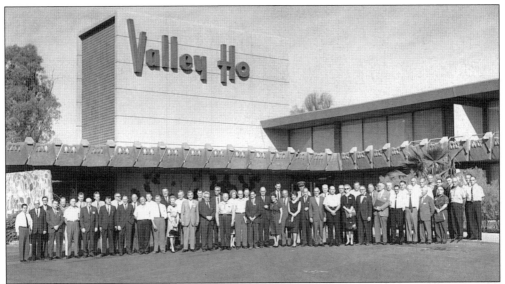

Hoteliers John Mills and Robert "Bobby" and Evelyn Foehl teamed up to build Scottsdale's premier year-round, European-plan, car-friendly resort hotel, the Valley Ho. It opened in December 1956 (staff photograph above), becoming a getaway for the Hollywood set. Robert Wagner and Natalie Woods held their wedding reception there in 1958 (below, with the Foehls at left). Bing Crosby, Jimmy Durante, Bert Lahr, Tony Curtis, Janet Leigh, Zsa Zsa Gabor, Marilyn Monroe, Betty Grable, James Cagney, Humphrey Bogart, and others stayed at the hotel, located at Main and Sixty-eighth Streets. Architects praise the historic hotel as a prime example of Mid-century Modern design. (Both Hotel Valley Ho.)

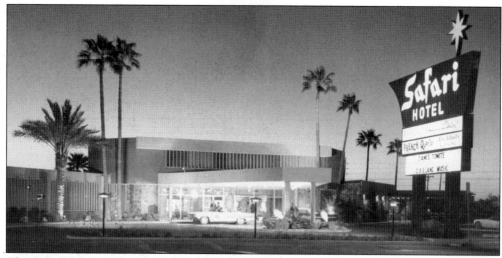

The Safari Hotel, on Scottsdale Road just north of Camelback Road, opened for the 1956–1957 winter season. It was a year-round, European-plan motor hotel. Inside Paul Shank's French Quarter dining room and nightclub offered patrons big-name entertainers and gourmet meals. The hotel's 24-hour coffee shop was a favorite of late-night revelers craving Swedish pancakes. The hotel was razed in the 1990s. (Scottsdale Historical Society.)

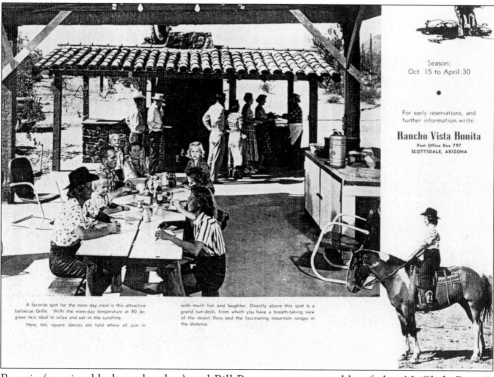

Season:
Oct. 15 to April 30

For early reservations, and
further information write:

Rancho Vista Bonita
Post Office Box 797
SCOTTSDALE, ARIZONA

A favorite spot for the noon-day meal is this attractive barbecue Grille. With the noon-day temperature at 80 degrees it is ideal to relax and eat in the sunshine. Here, too, square dances are held where all join in with much fun and laughter. Directly above this spot is a grand sun-deck, from which you have a breath-taking view of the desert flora and the fascinating mountain ranges in the distance.

Bonnie (wearing black cowboy hat) and Bill Puntenney managed her father N. Clyde Pierce's Rancho Vista Bonita, which opened in February 1950 at unpaved Pinnacle Peak and Pima Roads north of Scottsdale. Guests could ride horses in the desert, eat three meals a day, and stay in a private cabin for $12.50 per person per day. The remote guest ranch had to provide its own water and depended on a car radiophone for communication. (Peggy Puntenney Withers.)

New hotels on the European plan gave guests the choice of staying in or dining out. Dozens of restaurants opened to accommodate residents and visitors opting to dine out. In 1954, Bobby and Evelyn Foehl turned the old Saguaro Inn tavern on Main Street into the Lulu Belle, a gilded and ornate Gay Nineties (1890s)–themed restaurant and nightclub, complete with crystal chandeliers, lots of red velvet, dance hall-costumed waitresses, and "the longest bar in Scottsdale." Rudy Vallee and his wife joined the Foehls for this photograph. The Duke and Duchess of Windsor stopped by the Lulu Belle during their 1950s visit to Phoenix. (Hotel Valley Ho.)

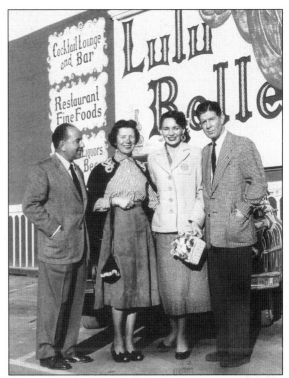

Pinnacle Peak Patio opened in 1957, expanding from a gas station to a rustic restaurant offering steaks grilled over an open fire to people en route to Bartlett Lake. The staff began cutting the neckties off any "dude" who dared wear one into the ultra-casual cowboy restaurant, tacking the ties on the ceiling, where they have accumulated by the thousands. (Scottsdale Historical Society.)

To meet the demand of Scottsdale's new "baby boom" generation, the Scottsdale School District started an aggressive expansion plan. The first new school since 1928, Tavan School (above) opened in February 1955 for kindergarten through eighth grade. Kachina, Ingleside, Tonto, Kiva, and Kaibab followed. Tonalea (below) was the last of the elementary schools to open during the 1950s, but several more schools were in the planning stages for the 1960s. (Both Scottsdale Historical Society.)

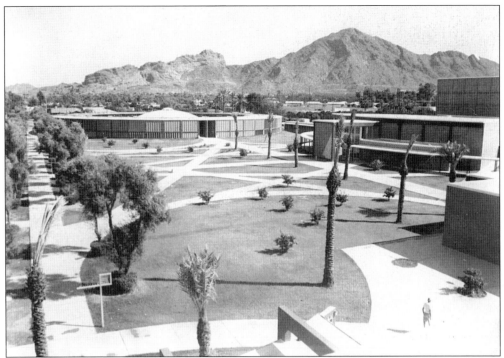

Arcadia High School, Scottsdale's second high school, opened in 1959 at 4703 East Indian School Road in the Arcadia District. Famous Titans from its early years include actress Lynda Carter, film producer Steven Spielberg, and translational genomics guru Jeffrey Trent. (Scottsdale Historical Society.)

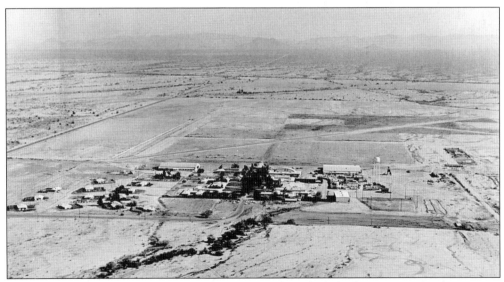

Private schools also stepped up to meet the demand of the baby boom. In 1953, the Arizona Conference of Seventh-day Adventists took over the facilities of Thunderbird II Airfield and opened Thunderbird Academy as a day and boarding high school. (Scottsdale Historical Society.)

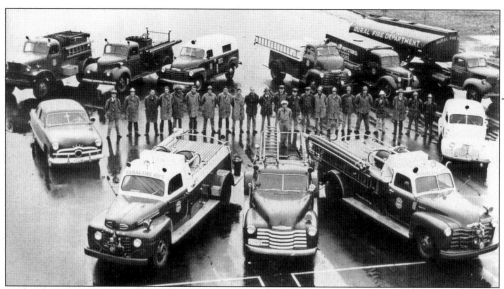

One of Scottsdale's first priorities after incorporating in 1951 was fire protection. In a bold move, the town council signed a contract with a private, Scottsdale-based service, Rural Fire Company, headed by founder Lou Witzeman (behind middle fire truck in white hat). This public/private partnership lasted over 50 years, until the City of Scottsdale established an in-house fire department in 2005. (Scottsdale Historical Society.)

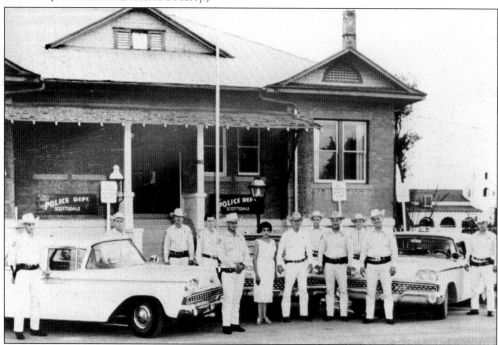

The new town council established police protection for its rapidly expanding population and tourists. Hurley Pruitt was hired as the Scottsdale's first town marshal. By the late 1950s, Scottsdale had its own small police force, operating out of the Little Red Schoolhouse. They maintained a holding cell in the basement. Police officers dressed in Western attire. The town's first female police officer was Lillian Shaheen (center). (Scottsdale Historical Society.)

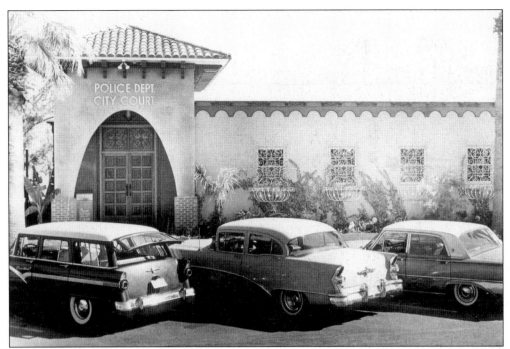

As the town expanded, so did its facilities. A police and city court building was erected next to the Little Red Schoolhouse. City council meetings and other public hearings were held in the courtroom. The building was torn down in the 1970s to make way for the west side of the Civic Center Mall, although its neighboring historic schoolhouse was saved. (Scottsdale Historical Society.)

One of the most recycled buildings in Scottsdale, the 1890s Adobe House became a volunteer-run library in 1955. In 1960, the Town of Scottsdale took over operation of the library and its 10,700 books. Children came to weekly story hours under the shade trees surrounding the library. Storage space was so tight that some books were stored in the inoperable oven and bathtub of the former home and guest ranch. In 1963, the library moved to the Little Red Schoolhouse. (Scottsdale Public Library.)

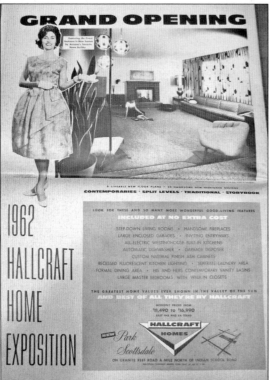

John Hall started building ranch-style Hallcraft homes in Scottsdale in 1951. Many veterans used their GI Bill benefits to buy the one-story homes with all the modern conveniences a family of the 1950s could want. In the 1960s, Hallcraft added townhomes to its mix of residential styles. Whole neighborhoods of Hallcraft homes sprouted up along Granite Reef Road and other areas around and south of downtown Scottsdale. When Motorola came to Scottsdale, its "white collar workers" snapped up Hall's homes and those of other builders as fast as they could be constructed. (Above, Scottsdale Historical Society; below, May Sue Tally, publisher of *The Arizonian*.)

Daniel Noble (right) and Paul Galvin are most responsible for bringing communications giant Motorola to Scottsdale, first in 1949 to the outskirts of Scottsdale and then in 1957 to a new plant on McDowell Road (below). Motorola employees and their families are credited with helping the Hotel Valley Ho survive its first summer as temporary residents waiting for homes to be built. Motorola families got involved in their children's schools, volunteered to serve on new town committees, and helped establish many of the town's civic organizations. (Both Scottsdale Historical Society.)

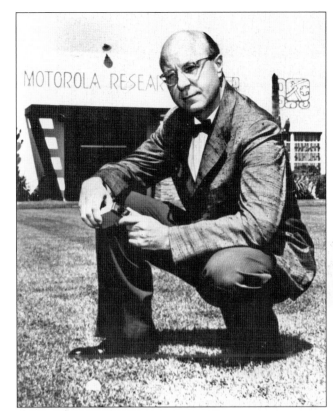

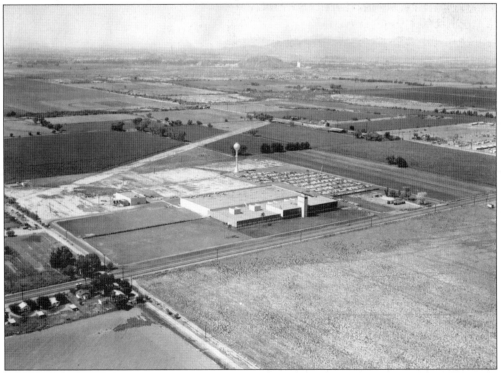

In 1955, Scottsdale's population topped 3,500, living on a few square miles of incorporated area surrounding downtown. As this photograph shows, there was plenty of land to grow north as tourists became residents, and residents grew their families. During the 1950s and 1960s, the town council was aggressive in its land annexations, occasionally sparring with Phoenix over desirable parcels located near the two cities. (Phil Schneider.)

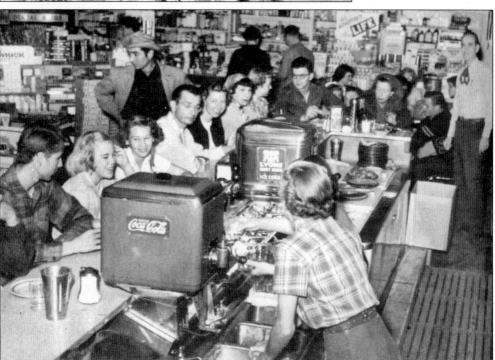

A feature in the December 3, 1960, issue of *Saturday Evening Post* declared Scottsdale "The town that millionaires built." Residents, particularly teens hanging out at the Lute's Pharmacy soda fountain, just thought of Scottsdale as a fun place to live, with horses to ride, jeans and cowboy hats the preferred dress, and where everyone knew just about everyone else. (Bill and Gail Wasbotten.)

Six

URBANE DESERT OASIS
WHERE THE WORLDS OF COMMERCE AND FUN CONVERGE
1961–1988

Scottsdale became a chartered city in 1961, with a population of just over 10,000 living on about five square miles. Tourism, arts and crafts, and a variety of large and small businesses were driving the economy, and life was good. In order to influence how their community would develop, citizens got involved in the Scottsdale Town Enrichment Program (STEP). From STEP meetings came major initiatives, like building a civic center, starting a community college, opening a municipal airport, and turning the often-flooded Indian Bend Wash into a series of parks rather than a proposed concrete flood-control channel.

As "The West's Most Western Town" matured, new groups stepped up to expand civic and charitable programs. The Scottsdale Charros formed to host baseball's spring training. Scottsdale harnessed the collective reach of area social service agencies to provide a range of services to citizens in need at Vista Del Camino. Scottsdale Leadership formed to ensure that a steady stream of informed, involved residents was prepared to lead the city into the future.

Scottsdale continued to annex land. The last large annexation in the mid-1980s extended the municipal boundary north to the Tonto Forest and boosted the city's size to 185 square miles. McCormick Ranch became the first of many master-planned communities to occupy newly annexed land. The city and businesses scrambled to keep up with growth, installing new infrastructure, building schools, and opening dozens of parks throughout the community. In 1985, Scottsdale began using its water allotment from the Central Arizona Canal in order to ensure adequate water supplies for its astounding growth.

More resorts opened, adding amenities like spas and championship golf courses. Jim Paul opened Rawhide, and the city opened WestWorld. Scottsdale's cachet as an arts and cultural community expanded to include city-sponsored public art, a performing arts center, and annual art events. Long a center for health seekers, Scottsdale finally got its own hospital in 1962, which, after several name changes, became Scottsdale Memorial Health Systems in the 1980s (now Scottsdale Healthcare). In 1987, Mayo Clinic opened on East Shea Boulevard. Armour Dial was the first large business to move into the Thunderbird Industrial Airpark; many others followed.

When Scottsdale celebrated its centennial in 1988, Herb Drinkwater was everyone's beloved mayor, the population approached 130,000, and forward-thinking citizens began to worry about overdevelopment of the Sonoran Desert and the city's signature McDowell Mountains. Scottsdale at 100 was proud of her past, enjoying her present, and engaged in planning for her future. Although some missed "the good old days," others believed that the best was yet to come.

In 1961, Scottsdale was chartered as a city and growing by leaps and bounds. City council meetings such as this one around 1964 or 1965 brought residents to air their concerns to Mayor Clayton and his council. During the 1960s, the council met in the courtroom of the Police and City Court Building next to the Little Red Schoolhouse. A Dee Flagg woodcarving is behind the council dais. (Scottsdale Public Library.)

In 1964, the city council asked residents to serve on Scottsdale Town Enrichment Program (STEP) committees in order to come up with innovative ideas to achieve major projects for Scottsdale. Dozens of men and women discussed for months how to get an airport, community college, civic center, and flood-control program. This photograph shows the kickoff STEP meeting in the courtroom/council chambers. (Scottsdale Historical Society.)

After years of lobbying the Maricopa County Community College (MCC) governing board, Scottsdale finally gained approval for Scottsdale Community College (SCC). Classes began in 1969 at Scottsdale High School before moving to temporary buildings at the college's new site in the Salt River Pima-Maricopa Indian Community. Shortly after classes began in September 1970 on the new campus, members of the STEP committee who had worked so long and hard to get a college joined MCC chancellor Dr. John Prince for a groundbreaking ceremony (above). The aerial view (below) shows the SCC campus in the early 1970s. The temporary buildings that served the "Artichokes" (the team name and college mascot) for many years form a semicircle of buildings on the left side of the photograph. (Both Scottsdale Community College.)

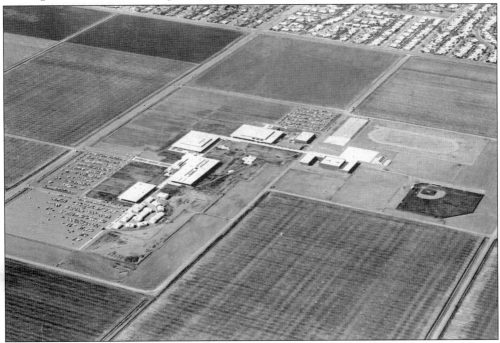

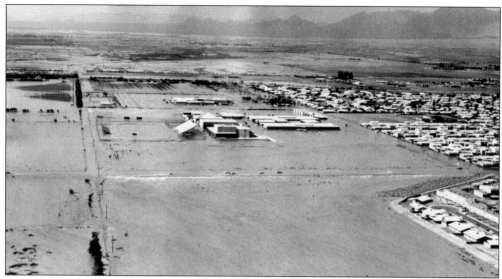

For decades, Scottsdale had been cut in half whenever the Indian Bend Wash flooded, as in this early 1970s view of Hayden Road (above, left) and Saguaro High School (above, center). STEP committees considered how to creatively solve the flooding problem. In a 1964 letter to the editor of the *Scottsdale Progress*, resident Bill Walton suggested a park-filled greenbelt in lieu of a concrete channel that the flood-control engineers might consider the most practical solution. Many embraced Walton's idea, but it took years of lobbying Washington, D.C., agencies, several bond issue votes, and a long-range vision to see the Indian Bend Wash Greenbelt Flood Control Project to its completion in the 1980s. Congressman Eldon Rudd (below, center) helped cut through federal red tape. Rudd is seen here with Mayor Bill Jenkins (below, right) and a U.S. Army Corps of Engineers official as they dedicate a portion of the project. (Above, Scottsdale Historical Society; below, City of Scottsdale.)

Yaqui Indian families living on land in the Indian Bend Wash were frequently flooded out of their homes. Using federal community development block-grant funds, the City of Scottsdale was able to relocate the families into trailers (above) while permanent homes were built for them on Roosevelt Street between Hayden and Miller Roads. The city also opened a social service and recreation center in 1973 (below), Vista Del Camino, adjacent to the new Yaqui neighborhood to serve all Scottsdale residents in their times of need. (Above, City of Scottsdale; below, Scottsdale Historical Society.)

Another goal of the STEP committees was to reopen the World War II–era Thunderbird II Airfield as a municipal airport. The Arizona Conference of the Seventh-day Adventists, who owned the former training airfield, gave Scottsdale the land and runway area for an airport, and SDL (the airport code for Scottsdale) opened in 1967. The Adventists then hired George Tewksbury to market their excess land around the airport as an industrial airpark. Companies began moving to Thunderbird Airpark in the late 1960s, with Armour Dial locating its research and development center on Scottsdale Road within the airpark in 1976. Renamed the Scottsdale Airpark, an array of corporate headquarters like Discount Tire, warehouse businesses like Price Club, and car dealerships like Schumacher European found the airpark to be a strategic location for their business as Scottsdale's population moved north. (Both City of Scottsdale.)

Businesses located in the Scottsdale Airpark could have direct taxiway access to their buildings. Here Don Reese of the airpark's marketing group Landel Inc. greets David Hallstrom, then-owner of Western Advertising, as he parks his aircraft in front of his business. Hallstrom, a former executive director of the Scottsdale Chamber of Commerce, was a strong supporter of the Scottsdale Airpark and its potential. (City of Scottsdale.)

Sen. Barry M. Goldwater was a true friend to the Scottsdale Airport, often flying in and out of the facility in his own plane. While in the U.S. Senate, or after his retirement back home to Paradise Valley, he was always available to dedicate something new at the airport, from the terminal, to the control tower, or to public art as seen here in 1989. The *At One With The Eagle* sculpture stands at the Butherus Drive entry to the airport. Sculptress Pat Mathiesen is in the center between Goldwater (podium) and Scottsdale mayor Herb Drinkwater. (Scottsdale Area Chamber of Commerce.)

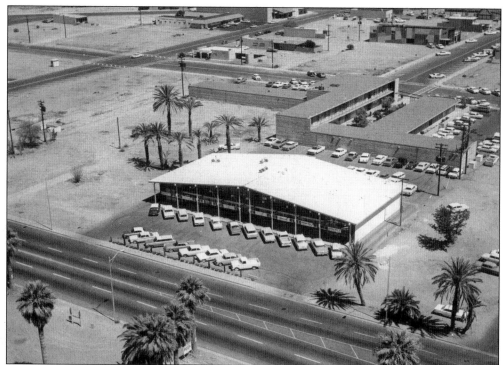

By the early 1960s, Scottsdale's city government had outgrown its hand-me-down space in the Little Red Schoolhouse. The city rented offices in the Triangle Building on Indian School Road while STEP committees and planners developed concepts for a civic center in the heart of downtown Scottsdale that would include a new city hall. (Scottsdale Historical Society.)

Arizona architect Bennie Gonzales was selected to design both city hall (above) and the Scottsdale Public Library to be surrounded by a landscaped, pedestrian-friendly mall or park. Completed in 1968, the buildings won Gonzales and the city many accolades for design and functionality. (Scottsdale Area Chamber of Commerce.)

The Bennie Gonzales–designed city hall and library also served as cultural venues until Scottsdale could build a performing arts center. The city invited musicians and performers to entertain children in the City Hall Kiva. The library's mezzanine became a showcase for Scottsdale's artists and traveling exhibits. (City of Scottsdale.)

When Scottsdale City Hall and the Scottsdale Public Library opened, the civic center vision was only half complete. It would take urban renewal funding, long-term planning, and lots of input from the arts community to finish the Civic Center Mall and add a performing arts center. Longtime residents in the neighborhoods west (top) of the new civic center would have to be relocated. (City of Scottsdale.)

Architect Bennie Gonzales (right) was selected as the lead architect to design the Scottsdale Center for the Arts. Reviewing plans with architect Richard Harris (left) and city executive Tim Bray (center), Gonzales would integrate the white stucco, Southwestern look of the arts center with his existing, award-winning city hall and library designs. (City of Scottsdale.)

Construction began on the Scottsdale Center for the Arts in 1974 (at right). Recognizing the need for more parking adjacent to the arts center, the city built a three-story parking garage (long structure in center) immediately behind the Little Red Schoolhouse, which by that time had become home to the Scottsdale Chamber of Commerce. (Scottsdale Historical Society.)

The Scottsdale Center for the Arts (above) opened on October 23, 1975, with a gala reception attended by the local "who's who" in art, culture, and politics. The featured performer was country singer Roger Miller (pictured at right in white), seen here with Scottsdale mayor Bill Jenkins. The following night, a play, *The Great American Nut Show* was presented. The new center also had a cinema where art and themed films and children's movies were regularly shown. (Above, Scottsdale Historical Society; right, City of Scottsdale.)

Scottsdale's Fine Arts Commission hired Russian-born sculptress Louise Nevelson to create a sculpture for the new Civic Center Mall. Seen here consulting with Scottsdale planning director Bill Walton, Nevelson unveiled her 15-foot-tall cor-ten steel *Windows to the West* in 1973 over a weekend of community festivities. This historic piece of public art is located between city hall and the library. (City of Scottsdale.)

Alternating between the Safari Hotel and Executive House Arizonian from 1961 to the mid-1970s, the Scottsdale National Indian Arts Exhibition introduced residents and visitors to famous Native American artists like painter Pablita Verlarde (left front) and potter Maria Martinez (right front). The artists are seen here with the exhibition's founder and Scottsdale gallery owner Paul Huldermann (left) and arts patron Dick LeRoy (right). (City of Scottsdale.)

During the late 1960s and early 1970s, Scottsdale staged a four-day All Indian Days Pow Wow. Hundreds of Native Americans from throughout the United States camped around Scottsdale Stadium and the Jaycees' rodeo arena, giving demonstrations of their native dances, costumes, crafts, and food. (City of Scottsdale.)

Banker Walter Bimson (right) was a great patron of the arts and commissioned work from many Scottsdale artists, like painter Francis Beaugareau (left), for branches of the Valley National Bank. Bimson participated in many acquisitions for Scottsdale's Fine Arts Program, of which he was a commissioner. (Scottsdale Historical Society.)

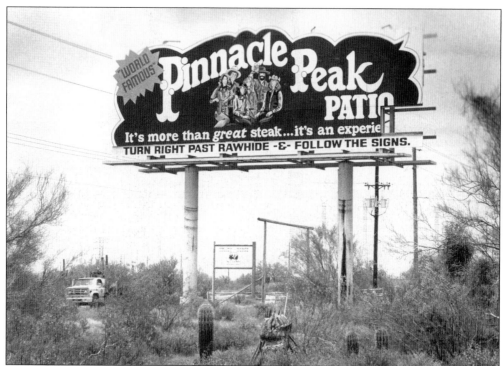

Concerned about every aspect of its visual attractiveness and wanting to make their community different from the rest, city officials in the early 1960s took a bold move. They banned billboards and began to enact strict sign ordinances that controlled the size and design of commercial signs on or in front of businesses. The measure enraged some merchants, who said the new rules would put them out of business because their customers would not be able to find them. These photographs are typical Scottsdale scenes before the ordinance required smaller, conforming signs and prohibited billboards. (Both Scottsdale Historical Society.)

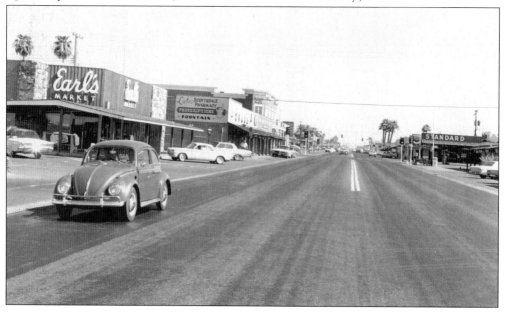

From the 1960s through the 1980s, more hotels and resorts opened in Scottsdale. The Executive House Arizonian opened on the southeast corner of Scottsdale and Chaparral Roads. Actress Jayne Mansfield, her husband Mickey Hargitay, and actor Preston Foster cut the ribbon at its November 1961 opening. In the 1970s, it became the SunBurst Resort Hotel (above) and renamed Caleo in 2005. In 1973, Minnesota businessman Bob Karatz opened the Scottsdale Hilton on the southeast corner of Scottsdale Road and Lincoln Drive (below). (Above, City of Scottsdale; below, Scottsdale Historical Society.)

The Registry Resort opened on the northeast corner of Scottsdale Road and Indian Bend in 1977 and featured famous entertainers in its nightclub. Across the street, the Scottsdale Sheraton opened, later changing its name to the Scottsdale Plaza Resort. Other upscale resorts opened further north—the Inn at McCormick Ranch, the Scottsdale Conference Resort, the Hyatt at Gainey Ranch, Thunderbird Suites at Scottsdale Airport, the Boulders, and others. (City of Scottsdale.)

One could always find something fun to do in downtown Scottsdale in the 1960s and 1970s. The Red Dog Saloon opened on Scottsdale Road, with a Western theme and famous nude painting, *Red Dog Rosie*. The new Kachina Theater featured Cinerama technology. Wild Bill Moses was a place for sing-alongs. The American Heritage Wax Museum on Stetson featured historic and celebrity likenesses. The Stagebrush Theatre opened on Marshall Way. (Scottsdale Historical Society.)

Trader Vic's opened its Polynesian restaurant on Fifth Avenue in 1962. That same year, John Wayne came to the premiere party for his movie *Hatari*, which was a benefit for the Phoenix Zoo. Also spotted there were Walter Winchell (who had a home in Scottsdale), Jane Russell, Eva Gabor, Merv Griffin, John Denver, and others. The restaurant closed in 1990, then reopened nearby in 2006. (Scottsdale Historical Society.)

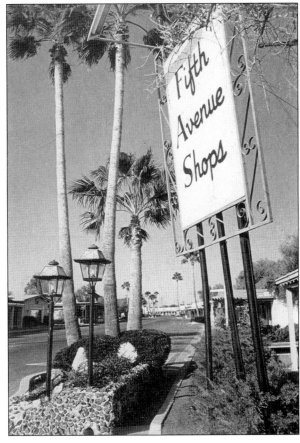

Fifth Avenue continued to offer an eclectic array of one-of-a-kind boutiques to shoppers, primarily visitors, throughout the 1960s, 1970s, and 1980s. Merchants staged an end-of-season Thieves Market that brought out bargain hunters. The gas lamps in the photograph demonstrate that at one time Scottsdale was billed as the Gas Lamp Capital of the World. (Scottsdale Historical Society.)

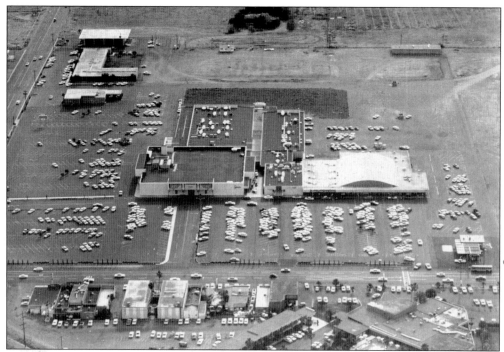

Goldwater's department store moved a few blocks north on Scottsdale Road to become the anchor tenant of the new Scottsdale Fashion Square when it opened in October 1961. Before the mall launched, the land on the northwest corner of Scottsdale and Camelback Roads had been the site of the Scottsdale Jaycees' Parada Del Sol rodeo arena. (Scottsdale Historical Society.)

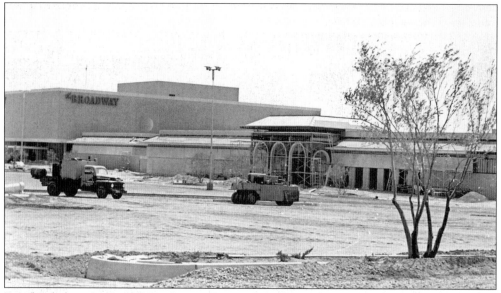

Farmland along McDowell Road east of Scottsdale Road gave way to Los Arcos Mall, which opened in 1969. It was the region's first fully enclosed mall, with The Broadway and Sears as its anchor tenants. The mall also drew patrons to its movie theater and a very popular Luby's Cafeteria. Los Arcos closed in the late 1990s and was torn down in 2001 to make way for new development. (Scottsdale Historical Society.)

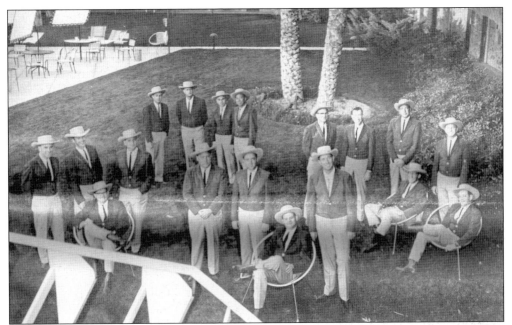

In 1962, the Scottsdale Charros (above) men's organization formed and assumed responsibility from the Scottsdale Baseball Club for hosting and staging spring-training baseball at Scottsdale Stadium. When the Charros formed, the Boston Red Sox were the resident team but were replaced by the Chicago Cubs in 1966 (below with Charros). The Oakland A's took to the field in 1979, and the San Francisco Giants made Scottsdale their spring-training home in 1982. The Charros sponsored other sporting events, with a goal of turning any monies raised over to deserving Scottsdale groups, particularly those involving youth and education. (Both Mae Sue Talley, publisher of *The Arizonian*.)

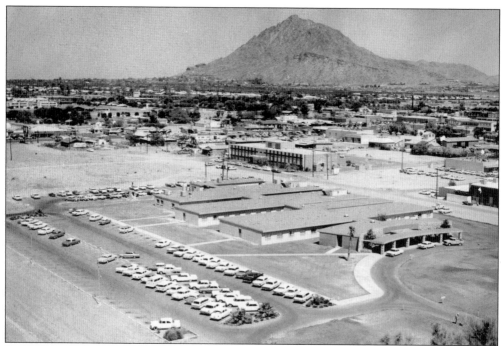

City Hospital of Scottsdale (above) opened on Osborn Road in May 1962. The hospital's auxiliary, formed a year before the facility opened, welcomed the community to an open house on Mother's Day in 1962, showing off their new medical facility (below). Within six months, the facility was renamed Baptist Hospital of Scottsdale. In 1971, it became an independent community hospital and renamed Scottsdale Memorial Hospital. During the 1970s, actor/comedian Dick Van Dyke chaired one of the hospital's capital campaigns while he was in town taping his television show at Carefree Studios. (Above, Scottsdale Historical Society; below, Scottsdale Healthcare Auxiliary.)

The Scottsdale School District pursued its growth plan into the 1960s and 1970s before enrollment patterns shifted and several schools closed. Paiute Elementary School opened in November 1961 on Osborn Road, then closed at the end of the 1980–1981 school year. The Dahlberg Corporate Center occupied the campus for the next decade. (Scottsdale Historical Society.)

Coronado High School opened as Scottsdale's third high school at the start of the 1961–1962 school year. Marshall Trimble, now the State of Arizona's official historian, was a history teacher there. Under the direction of art teacher Joseph Gatti, Coronado students created a distinctive mosaic on the side of one of the campus buildings. (Scottsdale Historical Society.)

Apache Elementary School opened on Eighty-fifth Place in February 1966, then closed at the end of the 1978–1979 school year after its enrollment declined. Like many other Scottsdale school buildings, Apache was recycled for other purposes, including use as the clothing bank for the city's Vista Del Camino social service center nearby. (Scottsdale Historical Society.)

Anne and Fowler McCormick's 4,200-acre ranch was sold to Kaiser-Aetna for $12.1 million in 1970. Using Scottsdale's new general plan as a guide, the huge tract was developed as the region's first master-planned community. It included a lake, two 18-hole golf courses, resorts, walking paths, and neighborhood retail centers. With so many families moving in, McCormick Ranch also required schools. (City of Scottsdale.)

Anne and Fowler McCormick and son Guy Stillman, seen here, donated the southeast corner of Scottsdale and Indian Bend Roads to the City of Scottsdale for use as a park. Guy, a lifelong railroad buff, helped the city develop the park with a railroad theme, opening in 1975. Zina Kuhn led the effort to relocate and restore a Gratitude Train Car to the park, one of 48 cars laden with gifts from the people of France after World War II. (City of Scottsdale.)

El Dorado Park became Scottsdale's first park when it opened c. 1967. The city considered naming it Clayton Park in honor of the late Mayor Clayton, or Coronado Park in honor of the nearby high school, but finally settled on the name El Dorado. (City of Scottsdale.)

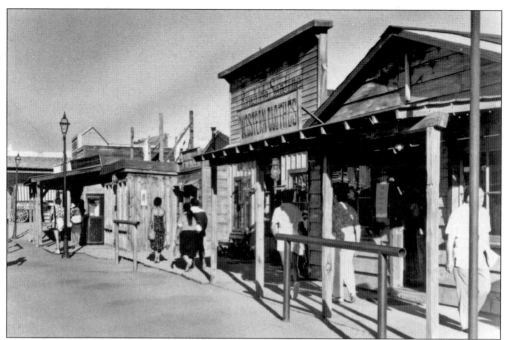

In the early 1970s, Jim Paul built Rawhide, a replica-1880s Old West town at the southeast corner of Scottsdale and Pinnacle Peak Roads (above). Millions came from around the world to "play cowboy" for a day, watching staged gunfights along Main Street, panning for gold, eating a cowboy steak in the saloon, or riding a hay wagon into the desert for a cookout under the stars. Rawhide hosted the Parada Del Sol Rodeo throughout the 1980s as well as the chamber of commerce's annual Cactus Capers travel-agent familiarization visits. Children of all ages loved the roaming farm animals and petting zoo (below). (Above, City of Scottsdale; below, author's collection.)

Louise Lincoln Kerr (right) was a talented musician and patron of the performing arts. She opened her home studio on the west side of Scottsdale Road just north of McDonald Drive to chamber musicians throughout the 1950s, then enlarged the studio to create an intimate performing arts space. She bequeathed the performing venue to Arizona State University, and the Kerr Cultural Center became a cultural gem for Scottsdale in 1981. (Scottsdale Historical Society.)

When the west side of Civic Center Mall was completed in the late 1970s, it included several restaurants and entertainment venues. Jed Nolan's Music Hall was a rip-roaring place to spend an evening. Next door to Nolan's was China Lil's, followed by Chez Louis, and a United Artists movie theater that fronted Second Street. A Doubletree Hotel opened on the north side of Civic Center Mall around 1976. (Scottsdale Area Chamber of Commerce.)

Scottsdale led the nation by adopting mechanized garbage collection in 1969. The long-armed truck was affectionately named "Godzilla," and its second model, seen here, "Son of Godzilla." The trucks and their crews gained national attention when they were featured in the *Weekly Reader* school newspaper in 1970. (City of Scottsdale.)

Saguaro and Coronado High School students became interested in garbage collection in the 1970s, too. They formed a recycling club and urged their classmates, families, and friends to recycle glass and newspapers long before it became a city requirement. Carla Woodall (center) began her environment activism as a Coronado student. (City of Scottsdale.)

Volunteering has always been important to Scottsdale residents. The Scottsdale Memorial Hospital Auxiliary found a fun way to volunteer while serving the hospital. They started parking cars for spring-training games during the Cubs era in the 1960s and expanded their volunteer role at Scottsdale Stadium through each succeeding team. (Scottsdale Healthcare Auxiliary.)

Community leaders from the City of Scottsdale, Scottsdale Chamber of Commerce, and Scottsdale Community College established the Scottsdale Leadership Program in 1986. Scottsdale Leadership Class I (pictured here) graduated in June 1987, sending its participants out to serve on city boards and commissions, nonprofit boards of directors, and in other community leadership roles. (Scottsdale Area Chamber of Commerce.)

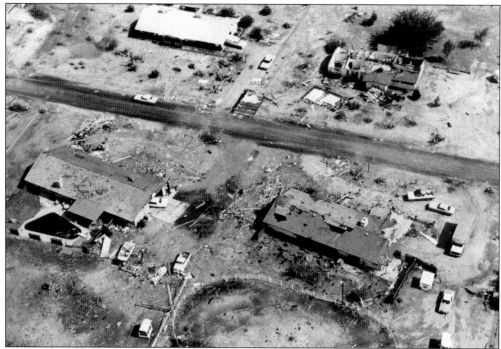

The equestrian corridor along Cactus Road took quite a hit on June 21, 1972, when a rare tornado touched down in Scottsdale. People were amazed to see utter destruction on one street and nothing touched on the next. (City of Scottsdale.)

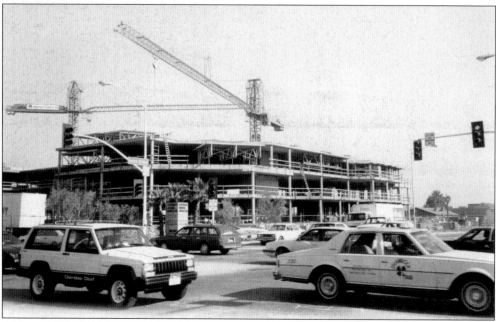

Although Winfield Scott's original homestead had been torn down in 1955 to make way for a Bimbo's drive-in, and later a Benihana restaurant, it wasn't until the 1980s that a multistory office structure was erected on the Scott site. A statue of Scott stands in the building's courtyard. (Scottsdale Area Chamber of Commerce.)

The Tournament Players Club of Scottsdale-Stadium Course opened in January 1987, just in time for the 1987 Phoenix Open. With rolling hills able to accommodate thousands of spectators, the TPC golf course was just what the Thunderbirds needed to make their signature Phoenix Open golf tournament even larger and, in turn, donate more to local charities. When it opened, the TPC was in the middle of undeveloped desert . . . but not for long. (City of Scottsdale.)

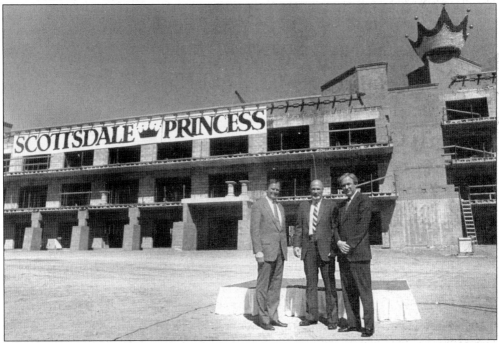

With the Tournament Players Club (TPC) golf course as its next-door neighbor, the Scottsdale Princess ultra-luxury resort opened in 1987 north of the Central Arizona Project canal. The Princess benefited from TPC tournaments as well as from horse shows and other events held at nearby WestWorld, which also opened in 1987. Here Scottsdale mayor Herb Drinkwater is flanked by unidentified Princess Hotels executives at the topping off ceremony. (Scottsdale Area Chamber of Commerce.)

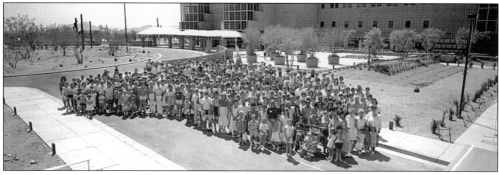

Mayo Clinic Scottsdale opened on East Shea Boulevard in June 1987 with 42 physicians, 220 support personnel, 120 exam rooms, and 1,800 appointments already scheduled. Paul Volcker, then chairman of the Federal Reserve board and a member of Mayo Foundation Board of Trustees, delivered the keynote address. Mayor Drinkwater welcomed Dr. Richard Hill as the chair of the Board of Governors of Mayo Clinic Scottsdale. On opening day, Mayo employees and their families gathered for this commemorative photograph. (Mayo Clinic.)

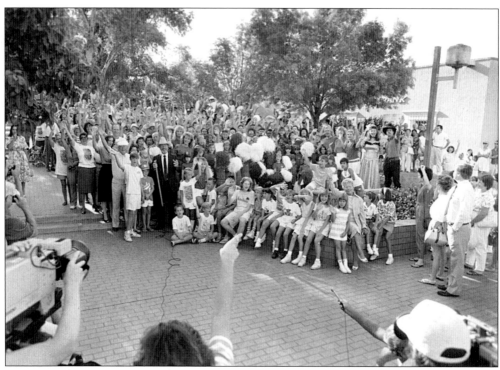

In 1988, Scottsdale celebrated the 100th anniversary of its founding, and ABC's *Good Morning America* was there to broadcast the "Howdy from Scottsdale" live to the rest of the nation. (Scottsdale Historical Society.)

BIBLIOGRAPHY

Dick, Wilburn W. *The History of the Scottsdale School System at Scottsdale, Arizona 1896–1944.* Tempe, AZ: Arizona State Teachers College, 1944.

Dudley, Shelly C. *Photographs Written Historical and Descriptive Data Reduced Copies of Drawings, HAER No. AZ–19.* Phoenix, AZ: Salt River Project, 1991.

Fudala, Joan. *Historic Scottsdale: A Life from the Land.* San Antonio, TX: Historic Publishing, 2000.

Kimsey, Bill. *Recollections of Early Scottsdale.* Scottsdale, AZ: self-published, 1987.

Lynch, Richard. *Winfield Scott: a Biography of Scottsdale's Founder.* Scottsdale, AZ: City of Scottsdale, 1978.

McElfresh, Patricia Myers. *Scottsdale: Jewel in the Desert.* Woodland Hills, CA: Windsor Publications, Inc., 1984.

Matthews, David S. *The Story of Scottsdale.* Scottsdale, AZ: self-published, 1965.

Melton, Brad and Dean Smith. *Arizona Goes to War.* Tucson, AZ: University of Arizona Press, 2003.

Moore, John Hammond. *The Faustball Tunnel: German POWs in America and Their Great Escape.* New York: Random House, 1978.

Palmer, K. T. *For Land's Sake,* Flagstaff, AZ: Northland Press, 1971.

Roman Associates. *A History of the Scottsdale Municipal Airport: June 1946–April 1986.* Report prepared for the City of Scottsdale: 1986

Roman, Bill. *Scottsdale Photo Album: Yesterday, Today.* Scottsdale, AZ: Scottsdale Tourist Guide, 1989.

Stuart, Richard M. and Richard Mullins. *The Phoenix Open: a 50 Year History.* Phoenix, AZ: The Thunderbirds, 1984.

The Taming of the Salt. Phoenix, AZ: Salt River Project, 1979.

Various collaborators. *The Yaquis of Scottsdale, Arizona.* Scottsdale, AZ: Concerned Citizens for Community Health, 2002.

ACROSS AMERICA, PEOPLE ARE DISCOVERING SOMETHING WONDERFUL. *THEIR HERITAGE.*

Arcadia Publishing is the leading local history publisher in the United States. With more than 3,000 titles in print and hundreds of new titles released every year, Arcadia has extensive specialized experience chronicling the history of communities and celebrating America's hidden stories, bringing to life the people, places, and events from the past. To discover the history of other communities across the nation, please visit:

www.arcadiapublishing.com

Customized search tools allow you to find regional history books about the town where you grew up, the cities where your friends and family live, the town where your parents met, or even that retirement spot you've been dreaming about.